IMAGES
of America

ARLINGTON
NATIONAL CEMETERY

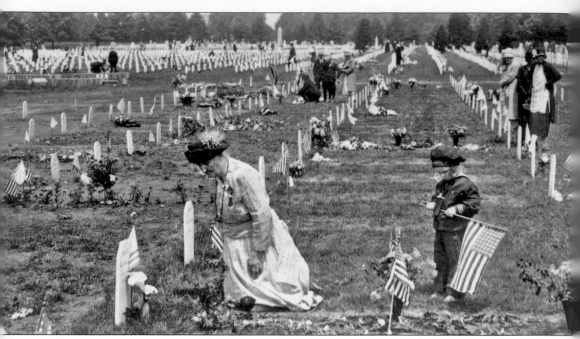

This is a 1929 Memorial Day photograph of families decorating the Arlington National Cemetery graves of soldiers who died in World War I. (Library of Congress.)

IMAGES
of America

ARLINGTON NATIONAL CEMETERY

George W. Dodge
with a foreword by Kim B. Holien

ARCADIA
PUBLISHING

Copyright © 2006 by George W. Dodge
ISBN 978-0-7385-4326-0

Published by Arcadia Publishing
Charleston, South Carolina

Printed in the United States of America

Library of Congress Catalog Card Number: 2006926780

For all general information contact Arcadia Publishing at:
Telephone 843-853-2070
Fax 843-853-0044
E-mail sales@arcadiapublishing.com
For customer service and orders:
Toll-Free 1-888-313-2665

Visit us on the Internet at www.arcadiapublishing.com

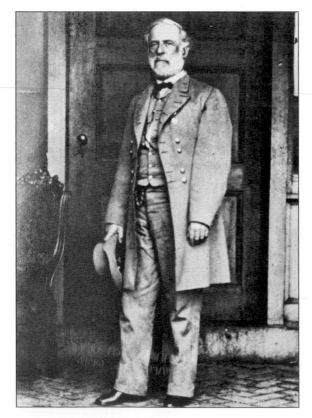

This 1865 photograph is of
Confederate general Robert E. Lee,
who married Mary Anna Randolph
Custis. She was the daughter of George
Washington Parke Custis, who built
and owned Arlington House. (Library
of Congress.)

CONTENTS

ACKNOWLEDGMENTS

This pictorial history consists of a number of photographs from the Library of Congress and some from the National Archives. The staff at each of these federal depositories of documents and photographs has always been accessible and helpful during my research efforts. I am also grateful to Kim B. Holien, author and Fort Myer historian, for his encouragement and assistance. Former sentinel of the Tomb of the Unknown Soldier Timothy Gerard has been supportive, as has World War II veteran Dick Kemp, photographer William F. Sale, and Arlingtonian Lurena Rice.

There are tens of thousands of compelling stories of those interred in Arlington National Cemetery that are waiting to be told. My regret is that I can only provide sketches of but a few of them. It is my desire that the accomplishments, courage, determination, and valor of the persons interred in Arlington become clear and evident in the vignettes that I have provided with the photographs. Accordingly this book is dedicated to the ideals of democracy, which are displayed in the deeds of the brave men and women buried in Arlington National Cemetery.

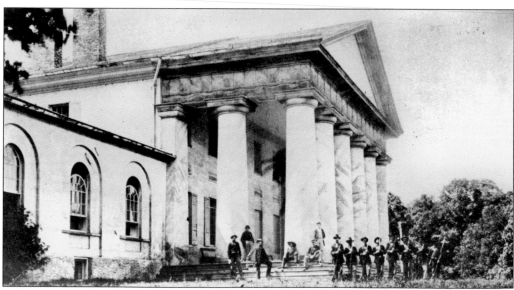

Armed Union soldiers are pictured during the Civil War at Arlington House on June 29, 1864. (Library of Congress.)

FOREWORD

When President Lincoln traveled to the small Pennsylvania town called Gettysburg in November 1863 to dedicate its National Cemetery, he referred to it as "Hallowed Ground." Throughout America today there is no more hallowed piece of ground than Arlington National Cemetery.

The Native Americans who originally inhabited this region were of the Algonquin language confederation belonging to Chief Powhatan of Jamestown fame of 1607. By the 1670s, they were gone, and Ship Master Robert Hanson became the first European to own this fair piece of land. He later sold it to the Scottish merchant John Alexander, who in turn sold it to the Custis family.

Upon reaching his majority in 1802, the title to the 1,100-acre estate was conveyed to George Washington Parke Custis, the adopted son (through his mother's second marriage) of George Washington. Having grown up at Mount Vernon, Custis decided to build the Arlington Mansion house as a museum memorial to his adopted father, George Washington. It took him 16 years, 1802–1818, to finish what we today know as the Custis-Lee Mansion, the southern wing of which housed priceless artifacts of George Washington.

In 1831, it was the location of the marriage of Mary Anna Randolph Custis to that young lieutenant of army engineers, Robert E. Lee. Arlington became their happy home from 1831 to 1861. The Civil War came in 1861 and changed Arlington into the hallowed ground that we know it as today.

Most Americans became acquainted with Arlington National Cemetery in 1963. It was the height of the cold war between America and the Soviet Union. The building of the Berlin Wall and the Cuban Missile Crisis were recent, international events.

In was in March 1963 that Pres. John F. Kennedy decided to visit the Custis-Lee Mansion and spend some time at the "Decision Room." This was the second-floor bedroom where Robert E. Lee had paced all night in April 1861 making his difficult decision whether to secede with Virginia or stay with the Union.

Drawing inspiration from visiting this room, President Kennedy, upon exiting the front of the mansion and seeing the magnificent view of Washington in the springtime, remarked, "Oh what a beautiful sight, I could stay here forever." When the tragedy happened in Dallas two years later, it became his destiny to return to Arlington to "stay here forever."

—Kim Bernard Holien
Historian for Fort Myer and Fort McNair

INTRODUCTION

The history of Arlington National Cemetery begins with the Custis family. John Custis, the only son of Martha Washington from her marriage to Daniel Custis—who died in 1757—was an officer on George Washington's staff during the American Revolution. In 1778, John Custis purchased the land of the current-day cemetery to be close to George Washington's Mount Vernon home. While Custis was dying of disease in November 1781, General Washington assured him that he would care of the youngest two of Custis's four children: George Washington Parke Custis, age six months, and Eleanor "Nelly" Custis, age two and a half—each of whom was raised at Mount Vernon. After George Washington's death in 1799, "Washington" Custis moved to the Arlington site with intentions of establishing a shrine for George Washington on the heights.

Washington Custis completed the building of Arlington House by 1818. To honor Washington, Custis placed in the mansion large oil portraits that he had painted commemorating Washington's battle triumphs. He also bought and collected artifacts of the former, first U.S. president to place at Arlington House. Custis married Mary Fitzhugh, and of their four children, only Mary Anna Randolph Custis lived past the age of three. On June 30, 1831, in a ceremony conducted at Arlington House, she married Robert E. Lee, an officer in the U.S. Army Corps of Engineers. Lee considered Arlington his home although he was stationed at various military posts from 1831 to 1861, including West Point. Washington Custis died in 1857, and Lee returned to Arlington to co-administer Custis's estate, which consisted of real property, debt, and numerous slaves.

When the Civil War broke out on April 12, 1861, Virginia had not seceded from the Union. However, on April 17, 1861, the Virginia Convention adopted an ordinance of succession. Lee had to decide whether to accept the offer from the federal government to command the Union army or to side with Virginia where he was born and where his family lived. On April 20, 1861, after deliberating during the night inside Arlington House and outside along Mary Lee's flower garden, Lee tendered his resignation to the U.S. Army. He then traveled to Richmond, Virginia, on April 22, 1861, stating "save in defense draw my sword on none." Within a few weeks, Mary Lee vacated her Arlington House home—never again to reside in its stately splendor.

On May 24, 1861, Union troops occupied the Arlington estate. Robert E. Lee became the commanding officer of the main Confederate army in the eastern theater of the war in June 1862. Against tremendous odds, Lee led his army until he surrendered on April 9, 1865, at Appomattox, Virginia. The cemetery was created upon orders from the Union quartermaster general during the Civil War. Arlington's humble origins as a potter's field have changed. The cemetery has evolved into a site in which several million persons conduct an annual pilgrimage to honor the dead.

—George W. Dodge
Arlington, Virginia
April 2006

One

THE UNION SOLDIER PRESENCE AT ARLINGTON DURING THE CIVIL WAR

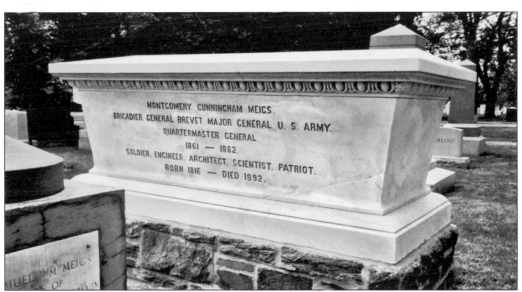

Numerous hospitals were in the Washington, D.C., region during the Civil War as a result of the casualties incurred at Virginia battlefields, where approximately 60 percent of the war was fought. In addition, camp diseases afflicted many of the Union soldiers stationed in the area to protect the Federal capital. By May 1864, Union forces renewed their annual Virginia campaigns, resulting in an increasing number of men in local hospitals dying from wounds and disease. Union quartermaster general Montgomery Meigs, a Southerner born in Georgia, had known Robert E. Lee before the war in the corps of engineers. Lee's resignation from the U.S. Army and his offer of service to the South was viewed by Meigs as a traitorous act. These factors were part of Meigs's consideration in selecting 200 acres surrounding Mary Lee's Arlington House as a cemetery, which would open on Friday the 13th in May 1864, with the interment of two young Pennsylvania privates.

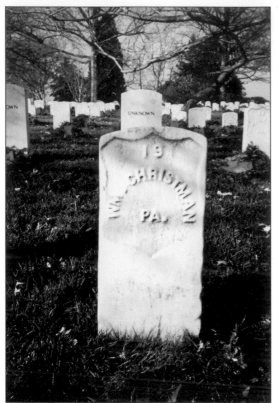

William Henry Christman was the first soldier interred in Arlington National Cemetery. He was born in 1843 in Lehigh County, Pennsylvania, the second son of Mary Ann and Jonas Christman. Christman, a 20-year-old farm laborer, left his family at Tobyhannah Township, Monroe County, and enlisted into the 67th Pennsylvania Infantry on March 25, 1864. On two occasions, Christman sent home his army pay to his parents, who used it to buy 226 acres of untimbered land. In a letter to his parents dated April 3, 1864, William asked whether his brother Timothy and sisters—Anna Maria, Emeline, Mary, and Sophia—were recovering from illness. He ended his letter by apologizing: "So please excuse my poor riting for I haf to write on my plait [plate] so I cant write as good as I ate." On May 1, 1864, William was diagnosed with the measles and died on May 11, 1864. His May 13 burial site is behind the wall (now demolished) to the left of the gate.

Ord & Weitzel Gate, Arlington Cemetery, Va

William H. McKinney of the 17th Pennsylvania Cavalry was the second soldier buried in Arlington. McKinney, at five feet, six inches in height with brown eyes and dark hair, enlisted on March 16, 1864. John McKinney, William's father, consented to his 17-year-old son's entry into the cavalry instead of continuing work at an Adams County sawmill. Writing from near Arlington, Virginia, to his family on March 25, 1864, McKinney's letter included $50 and the comment that "[F]ortifications throwed up here that the Devil would hardly get through let lone the rebbles [rebels]." McKinney was then admitted to a hospital in Alexandria, Virginia, with a diagnosis of pneumonia. With his father at his bedside, William died on May 12, 1864, after 57 days in the cavalry. McKinney's burial site is visible in this 1906 photograph. Within a year, over 5,000 soldiers, mainly privates, would be buried in Arlington Cemetery.

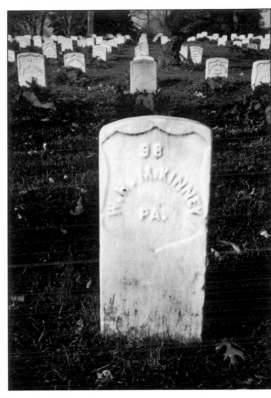

11

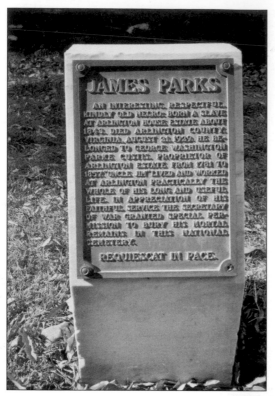

JAMES PARKS

AN INTERESTING, RESPECTFUL, KINDLY OLD NEGRO, BORN A SLAVE AT ARLINGTON HOUSE ESTATE ABOUT 1843. DIED ARLINGTON COUNTY VIRGINIA, AUGUST 21, 1929. HE BE-LONGED TO GEORGE WASHINGTON PARKE CUSTIS, PROPRIETOR OF ARLINGTON ESTATE FROM 1831 TO 1857. UNCLE JIM LIVED AND WORKED AT ARLINGTON PRACTICALLY THE WHOLE OF HIS LONG AND USEFUL LIFE. IN APPRECIATION OF HIS FAITHFUL SERVICE THE SECRETARY OF WAR GRANTED SPECIAL PER-MISSION TO BURY HIS MORTAL REMAINS IN THIS NATIONAL CEMETERY.

REQUIESCAT IN PACE.

It appears that the initial graves, as well as other graves at Arlington, were dug by James Parks—a former slave of George Washington Parke Custis, pictured below. At 2:00 p.m. on May 13, 1864, a funeral service for McKinney and Christman was conducted by a chaplain, perhaps Rev. E. W. Jackson as he is recorded as presiding over services the following week. It is likely that Parks was present. John McKinney, who presumably could not afford for his son to be embalmed and transported to Pennsylvania, was also present to see his son interred in an isolated corner of the Arlington estate. Little did Parks or McKinney realize that the potter's field in which they witnessed the burial of two young Pennsylvanians would someday become a renowned military cemetery. When James Parks died in 1929 at age 86, his interment was on the land where he had been born a slave in 1843. (Library of Congress.)

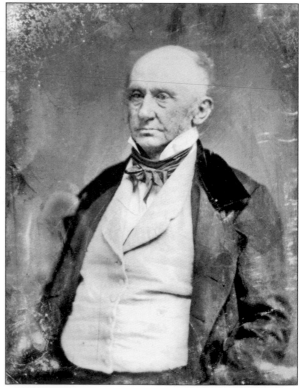

William Blatt, a 19-year-old native of
Berks County, Pennsylvania, enrolled
in the 49th Pennsylvania Infantry on
September 1, 1861. At the Battle of
Spotsylvania, Virginia, 12 Union regiments
were selected to attack a section of the
Confederate line over open ground on
May 10, 1864. One of the lead regiments
was Blatt's unit, which sustained more
than 50 percent casualties—260 soldiers
killed or wounded—the highest Union
regimental loss in the attack. Blatt received
a gunshot wound to the head and died
on board the hospital ship transporting
him to Washington, D.C. On Saturday,
May 14, 1864, the second day of burials,
the five-foot-nine-inch Blatt was only the
third soldier buried in Arlington's new
"Soldier's Cemetery" and the first battle
casualty of what would evolve into a
prestigious military cemetery. Also shown
is an early-1900s photograph of the George
B. McClellan Gate. Blatt served under
General McClellan in 1861–1862.

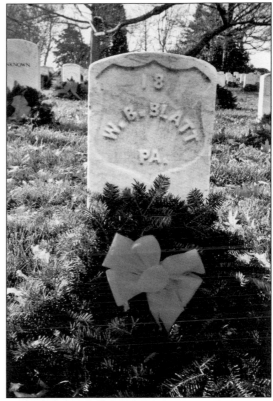

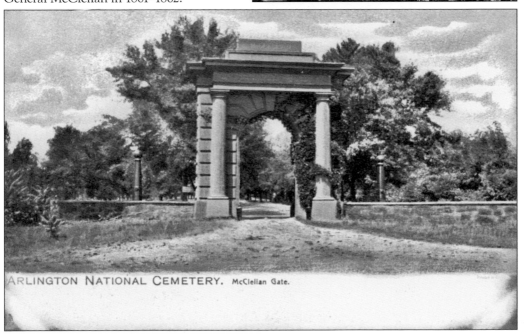

ARLINGTON NATIONAL CEMETERY. McClellan Gate.

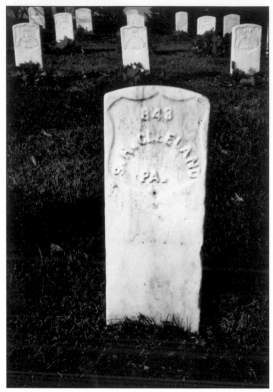

Samuel H. Cleland, incorrectly spelled Cleeland here, enlisted in the 100th Pennsylvania Infantry. Born in Pennsylvania, Cleland was five feet, five inches tall with blue eyes and blonde hair. Before the war, he was an apprentice blacksmith with his father, William. Samuel resided at Portersville, north of Pittsburgh, with his father, mother, Harriett, and younger siblings William and Olive—all Pennsylvanians. Cleland would soon travel to Virginia, the nativity of his paternal grandmother, to join his unit. On May 12, 1864, his regiment engaged entrenched Southern soldiers at a distance of 60 yards near Spotsylvania Courthouse, Virginia—one of the most severe days of fighting during the Civil War. The 18-year-old Cleland was wounded and died on June 2, 1864. (U.S. Army Military History Institute, Kraus Collection.)

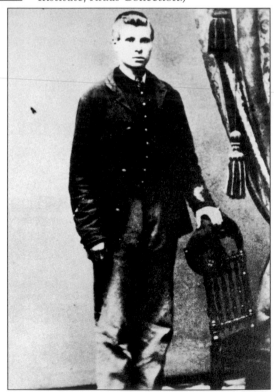

Capt. Albert H. Packard is the first officer, first soldier from a Maine regiment, and 24th soldier overall buried in Arlington Cemetery. In this c. 1862 view, Packard's interment site would be behind the figure standing in the photograph. In 1862, Packard left his wife, Elizabeth, two children, and mechanic's job to enlist in the 19th Maine Infantry. In the 1863 Battle of Gettysburg, the regiment would sustain over 45 percent casualties. On May 6, 1864, the second day of the Battle of the Wilderness in Virginia, Packard, now captain of the 31st Maine, received a fatal gunshot wound. He was interred on May 17, 1864, the fifth day of burials. In 1908, Elizabeth died and was buried with him.

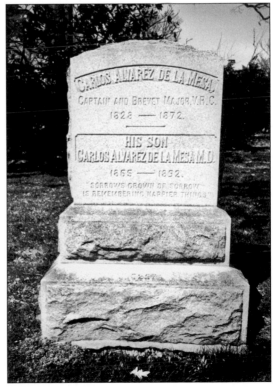

Capt. Carlos De La Mesa has a private marker, at right, along Mary Lee's flower or rose garden. A native of Spain and former ensign in the Spanish Navy, he was wounded at Gettysburg on July 2, 1863. He died in 1872 with four children for his wife, Fannie, to raise in Brooklyn, New York.

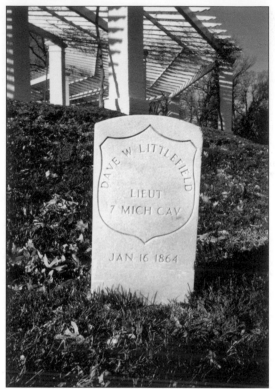

Daniel Littlefield was born in Cicero, New York, and was a clerk before the war. He was in action at Seven Pines on May 31, 1862; was promoted October 30, 1862, as a lieutenant in the 7th Michigan Cavalry; and participated in the 1863 Gettysburg Campaign. In the October 1863 photograph below near Warrenton, Virginia, the six-foot-tall, fully bearded Littlefield is standing next to a seated Gen. George Armstrong Custer, his commanding officer. In the following month, Littlefield contracted smallpox. On January 4, 1864, at the age of 25, he died from this contagious disease and was buried in Harmony Burial Grounds. He was disinterred and buried near Mary Lee's flower garden—an officers' burial site selected by Gen. Montgomery Meigs. Daniel's grave marker incorrectly cites his name as Dave and errantly lists his date of death as January 16.

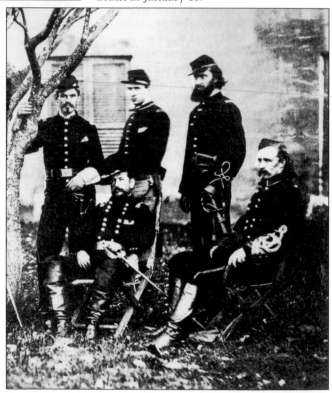

The 39th New York Infantry, known as the Garibaldi Guard, was an immigrant regiment named after Italian military leader Giuseppe Garibaldi. The regiment sang as it marched over the Long Bridge into Arlington in May 1861. On July 4, 1864, the unit marched before Pres. Abraham Lincoln. Among the soldiers on review was 21-year-old Johanni DeLacosta—a native of Italy. He was wounded in action near the Po River, Virginia, on May 10, 1864, and died June 28. The graves of DeLacosta and other Union soldiers surround the burial plot of the builder of Arlington House, George Washington Parke Custis, who died in 1857. In the 1920s photograph below, obelisks mark the interment site of Custis, who was raised at Mount Vernon by George Washington and Martha Washington, his aunt. His spouse, Mary Fitzhugh Custis, died in 1853 and is buried next to him.

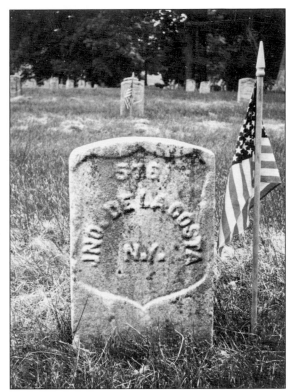

Pictured is the four-foot-high obelisk of William Baldwin of the 14th Brooklyn (below) and a 19th-century reversed picture of the same "Field of the Dead" with 15 posing laborers (above). Baldwin's New York State Militia unit, wearing red pants and known as the Red Devils, crossed the Potomac River into Virginia on May 23, 1861, and camped near Arlington House. On July 21, 1861, Baldwin was wounded in the first major battle of the Civil War, Bull Run, a Federal defeat. He lived just long enough to see the Union win the war as he died from his wounds on June 5, 1865. The Quartermaster General's Office purchased the 29-year-old Baldwin's distinctive marker.

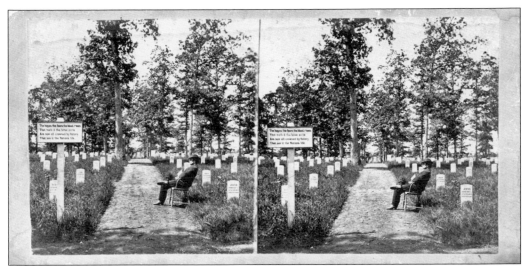

Cpl. John Igo of the 155th New York Infantry was wounded on June 3, 1864, at the Battle of Cold Harbor, Virginia, and died 12 days later. Igo was one of 7,000 Union casualties that day. His marker in the c. 1880s photograph above is numbered 2,935 and is behind the seated figure. Also buried in the Field of the Dead is Job Tanner, a 27-year-old carpenter residing in Providence, Rhode Island, in 1860. He enlisted in the 2nd Rhode Island Infantry on August 1, 1861. Tanner fought in the 1862 Peninsular Campaign and was in the 1863 battles of Chancellorsville and Gettysburg. While serving as corporal of the color guard, Tanner was shot at the Battle of the Wilderness, Virginia, on May 6, 1864, and died on July 16. During the Civil War, 110,000 Union soldiers were killed or died from wounds.

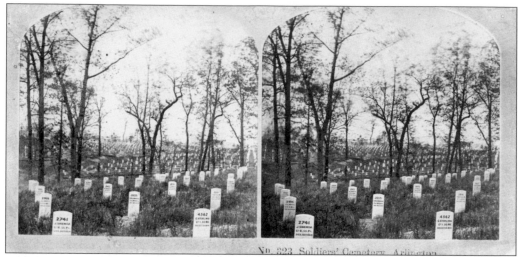

No. 323 Soldiers' Cemetery, Arlington

Jacob Schoenick, the front left marker of this stereoview, of the 55th Pennsylvania Infantry was wounded on June 3, 1864, during the Union defeat in the Battle of Cold Harbor, Virginia. His amputated left leg showed "signs of gangrene" on June 30. Schoenick, a six-foot-one-inch, 30-year-old laborer born in Germany, died and was interred in Arlington Cemetery on July 10, 1864, at 3:00 p.m. Another soldier, 18-year-old Nelson W. Edwards, the center headstone, of Poland, Maine, died of wounds received May 19, 1864, at Harris' Farm—the conclusion of nearly two straight weeks of heavy fighting at Spotsylvania, Virginia. Leaving behind his parents, Humphry and Mary, and five siblings, Edwards had been in the 1st Maine Heavy Artillery for six months. This unit, fighting as infantry, had the highest number of men killed in battle of the 2,047 Union regiments in the Civil War.

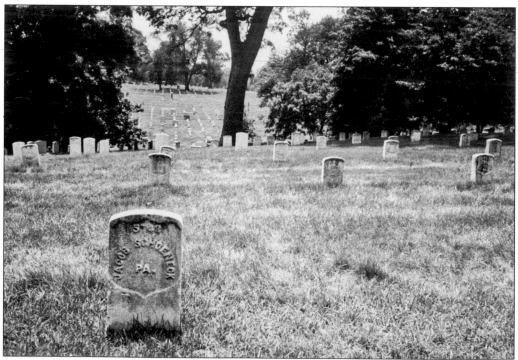

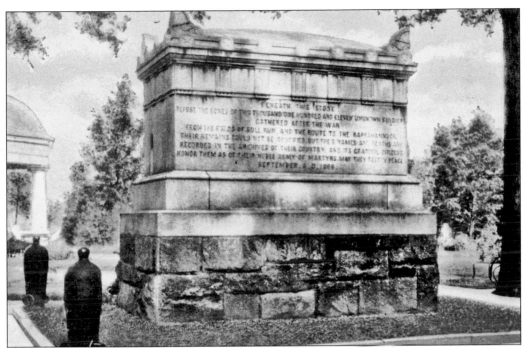

Within the flower garden of Mary Lee, wife of Gen. Robert E. Lee, is a pit, 20 feet deep, that was dug in 1865 to place the remains of unknown soldiers gathered mainly from Northern Virginia battlefields. The inscription on the sarcophagus cites the interment of 2,111 soldiers. Until the Tomb of the Unknown Soldier (built in 1921), the Civil War Tomb of the Unknown Dead was the first honoring unknown soldiers in Arlington Cemetery. It is within 180 feet of Arlington House and was observed by Mary Lee during her 1866 visit. She later wrote, "They have done everything to debase and desecrate [Arlington]." Joseph Mann, a 21-year-old of the 2nd Wisconsin Infantry, is likely buried in the tomb. Mann, a student before the war, was one of 86 soldiers of his unit killed on August 28, 1862, at the Battle of Brawner's Farm, Manassas, Virginia, and buried on the field. In 1865, a reinterment detail located the remains and placed them in the tomb. (State Historical Society of Wisconsin.)

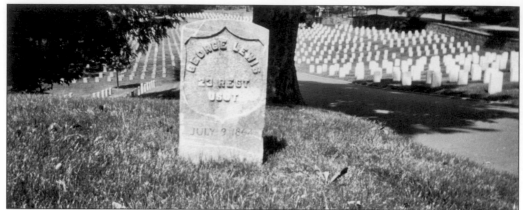

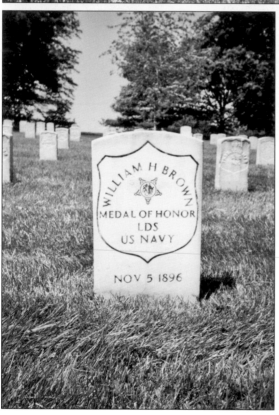

The above photograph is of Section 27—the burial site of 19-year-old Virginia native George Lewis. In July 1864, he enlisted in the 23rd United States Colored Troops (USCT). Lewis died on July 9, 1864, from fever and pneumonia. About 179,000 black men served in the U.S. Army and 10,000 served in the U.S. Navy in the Civil War. This represented 10 percent of all Union forces. The 23rd USCT lost 165 enlisted men to disease—twice as many as were killed or mortally wounded. The units' two-to-one ratio of deaths attributable to disease compared to those killed in action is the same ratio of deaths of all Union and Confederate forces. William H. Brown of Baltimore, Maryland, was one of seven black sailors of the U.S. Navy who received the Medal of Honor in the Civil War. He was on board the USS *Brooklyn* during its August 5, 1864, attack at Mobile Bay, Louisiana.

Hundreds of recently freed slaves living at the Freedman's Village on the southern end of the Arlington estate (close to the Pentagon) perished from disease while attempting to learn skills in the new industrial era. The markers of these newly free men and women recognize their new status as citizens under the 14th Amendment of the U.S. Constitution. Henry Dorsey, a free man and native of Allegheny County, Maryland, enlisted in July 1863 into the 6th USCT. The motto on the units' flag was "Freedom For All." On July 30, 1864, at the Battle of the Crater near Petersburg, Virginia, Dorsey was struck by a shell fragment. He died on February 3, 1865, at Armory Square Hospital and was buried on February 5. Surviving Dorsey was his father, James Dorsey. (Library of Congress.)

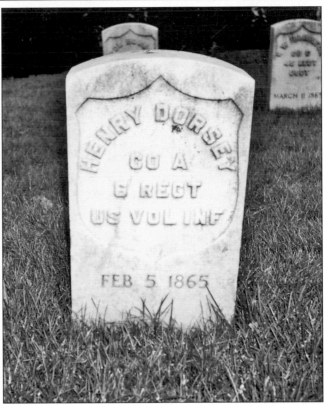

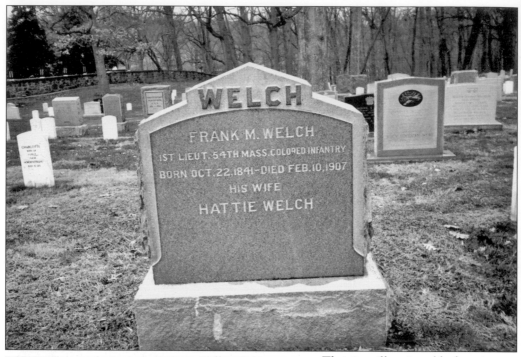

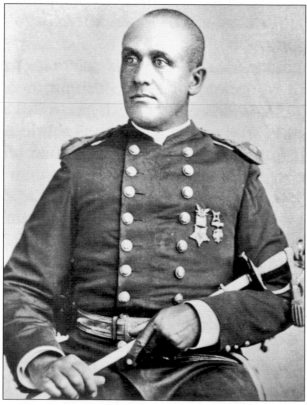

The most illustrious black regiment of the Civil War was the 54th Massachusetts Infantry, which was popularized in the 1990 film *Glory*. In the ranks of this unit was Lt. Frank M. Welch—one of approximately 109 black commissioned officers in the war. A native of Philadelphia, he lived in West Meriden, Connecticut, and worked as a barber. On July 18, 1863, at 7:45 p.m., Welch advanced with 624 members of his unit (and with white soldiers from other regiments) along the beach at Morris Island, South Carolina. Col. Robert Shaw was killed on the parapet of Fort Wagner after shouting, "54th forward." On this day, the fort was impregnable, and the 54th sustained 45 percent casualties, including Welch who was wounded in the neck. After the war, Welch maintained a military career culminating as a major in the Connecticut National Guard.

The 61st burial at Arlington was Confederate soldier Michael Quinn of the 13th Mississippi Infantry. On May 8, 1864, the 33-year-old Irishman was wounded in the shoulder and captured at Spotsylvania, Virginia. He died on May 16 and was buried two days later, the sixth day of burials on the land where his commanding general, Robert E. Lee, once lived. Also interred near the Confederate Memorial in this *c.* 1916 photograph (below) is 34-year-old William Stone of the 1st South Carolina Cavalry, who was shot and captured in the June 8, 1863, Battle of Brandy Station, Virginia—the largest cavalry battle fought in the western hemisphere. A farm laborer from Chester, South Carolina, Stone had a wife, Margaret, and three children, William Jr., Margaret, and Edward. Stone died on June 17, 1863, and was interred in the Soldier's Home Cemetery in Washington, D.C. He was reburied in Arlington Cemetery in 1901.

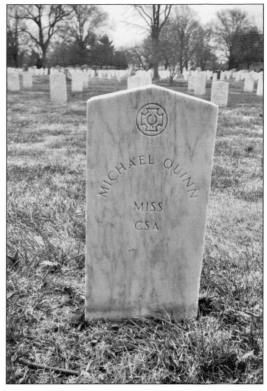

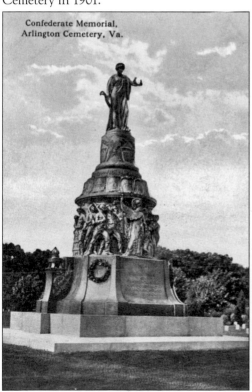

Confederate Memorial,
Arlington Cemetery, Va.

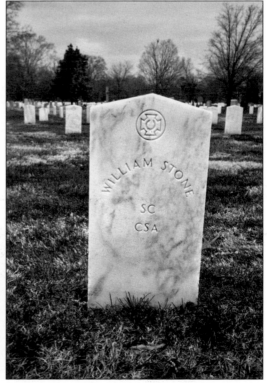

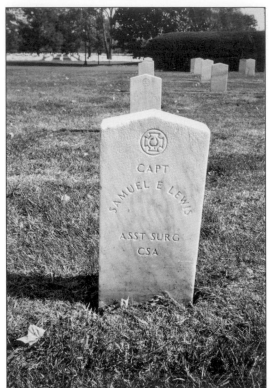

In 1863, Samuel E. Lewis (below) began attending lectures at Richmond's Medical College of Virginia. The 25-year-old Lewis was commissioned as an assistant surgeon in 1864. He tended to some of the thousands of wounded and ill Confederate soldiers admitted to Chimborazo Hospital in Richmond, Virginia. After the war, Lewis practiced medicine in Washington. He discovered that the graves of Confederate soldiers located in Arlington and at the Soldier's Home Cemetery in Washington had deteriorating markers. These soldiers had been prisoners when they died of disease or from their wounds. Lewis presented to Pres. William McKinley his idea for a designated Confederate section at Arlington Cemetery. The administration supported the plan, and Congress appropriated funds in 1900. The remains of 264 Confederate soldiers were exhumed and reinterred in this new section in 1901.

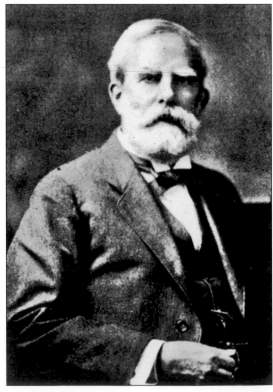

Mary T. Thompson was a charter member of a local chapter of the United Daughters of the Confederacy (UDC). Described as gentle, modest, intelligent, and with executive ability, Mary Thompson had the idea of a Confederate monument at Arlington to honor rank-and-file soldiers. At a UDC convention, Thompson stated that at Arlington there must be a "national reminder of the valor and heroism of our fallen braves." Through her efforts, and those of other UDC leaders, $75,000 was raised between 1906 and 1917 for the monument. Thompson was so influential that a memorial association was named after her, and she had the sobriquet "Mother of the Confederacy." The monument was unveiled in 1914, and Mary died the next year. The Confederate headstones of white marble are pointed, according to legend, to prevent Union sympathizers from sitting on them.

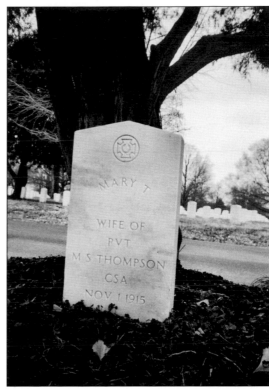

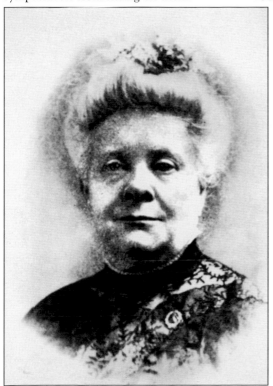

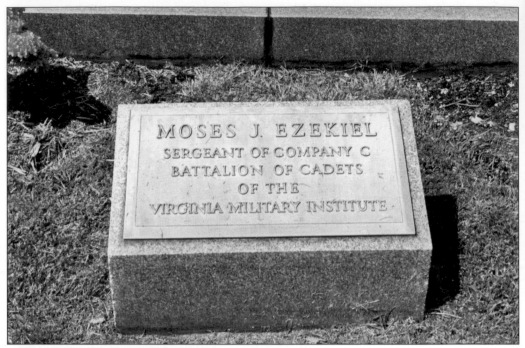

MOSES J. EZEKIEL
SERGEANT OF COMPANY C
BATTALION OF CADETS
OF THE
VIRGINIA MILITARY INSTITUTE

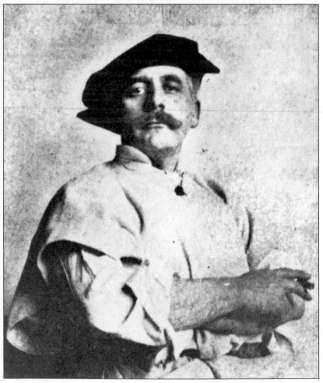

By Sunday morning, May 15, 1864, some 247 cadets of the Virginia Military Institute (VMI) had marched on the Shenandoah Valley Turnpike to New Market, Virginia. The predominantly teenage cadets united with 4,500 veteran Confederates to oppose 6,000 Union soldiers. At about 2:30 p.m., with the outcome of the battle still in doubt, the Confederates, including the VMI cadets, attacked the Union position on Bushong's Hill. The VMI students engaged in hand-to-hand combat, capturing Union soldiers and cannon at a cost of 10 killed and 47 wounded. Among the cadets was Sgt. Moses Ezekiel, who had entered VMI in 1862. Ezekiel graduated, and in 1869, he went to study sculpture at the Royal Academy of Art in Berlin. He moved to Rome in 1874 to set up his studio at the Baths of Diocletian.

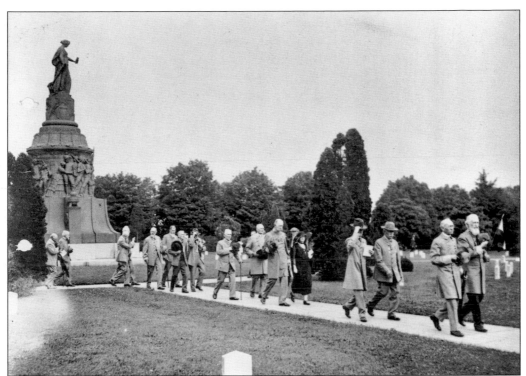

In the twilight of his career, Ezekiel began creating bronze Civil War monuments such as *Virginia Mourning Her Dead* on the VMI campus at Lexington and what he considered his masterpiece—*New South*. The 32.5-foot-high bronze monument was unveiled on June 4, 1914, with Pres. Woodrow Wilson as the principal speaker. Confederate veterans are shown above leaving after its 1914 dedication. The intended theme of the *New South* monument is peace, reunification, and heroism with a larger-than-life size figure representing the South wearing an olive leaves crown. Her right hand is on a plow stock with a pruning hook to symbolize the Biblical verse in Isaiah: "And they shall beat their swords into plow shares and their spears into pruning hooks." Four cinerary urns and 32 life-size figures depicting the sacrifices of the South encircle the monument. (Library of Congress.)

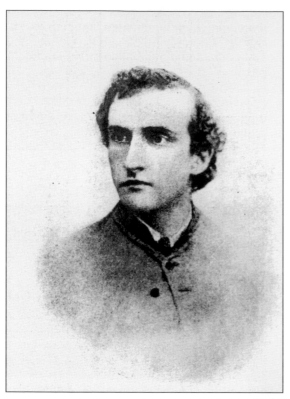

Alexander Hunter, at left, and his father Bushrod—a pallbearer for the funeral service of George Washington Parke Custis—left their 430-acre Abingdon plantation adjacent to the Arlington estate to join Confederate forces in 1861, like their neighbor Robert E. Lee and his sons. Alexander Hunter enlisted in the 17th Virginia Infantry. At Second Manassas on August 29, 1862, Hunter was wounded in the arm during a Confederate assault near the Chinn House. In the Battle of Antietam, Maryland, on September 17, 1862, Hunter was captured and released. Another casualty at Antietam was Lt. Thomas Cowan Jr., a 24-year-old Brunswick, North Carolina, lawyer, who was mortally wounded leading Company B of the Third North Carolina into the battlefield later known as "the Cornfield." Total Union and Confederate losses on that day were 24,412.

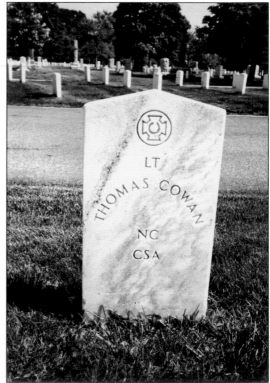

In 1864, the Arlington and Abingdon estates were confiscated by the federal government. George Washington Custis Lee, son of Robert E. Lee, filed suit in 1877 to recover Arlington. He was victorious in trial and on appeal. In 1883, he accepted $150,000 to deed the Arlington estate and cemetery to the national government. Hunter, the owner of Abingdon plantation, also took legal action and succeeded in recovering his land. One of his lawyers was James A. Garfield, a Union general who became president of the United States in 1881. After the war, Hunter worked in the federal General Land Office and wrote. His books include the highly quoted *Johnny Reb and Billy Yank* and *The Huntsman of the South*. Hunter's postwar picture below depicts him with a haversack full of corn as he drinks from a canteen. He died in 1914 and is buried just a few miles north of his Abingdon home.

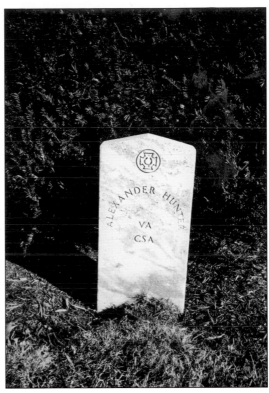

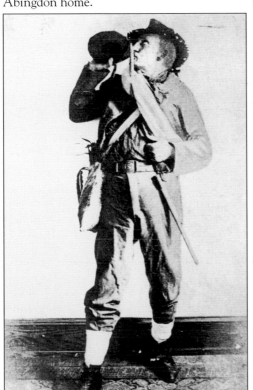

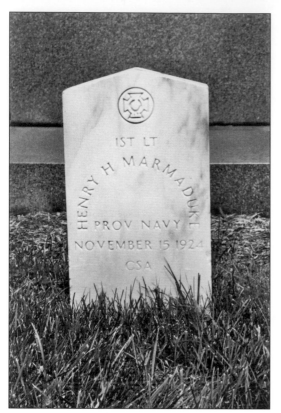

Henry Marmaduke, while directing a gun crew of 14 men on board the CSS *Virginia* (former USS *Merrimac*), received an arm wound in the Battle of Hampton Roads on March 9, 1862, against the Federal ship the *Monitor* in the historic first battle between two ironclad vessels. The day before, he had been on the ironclad during its destruction of U.S. ships the *Cumberland* and the *Congress*. A native of Arrow Rock, Missouri, midshipman Marmaduke resigned from the Naval Academy in March 1861. Both his father, Meredith, a Unionist, and his brother, John, a Confederate general, served as governors of Missouri. Two other brothers were killed in the Civil War. Marmaduke is interred at the base of the New South monument—the tallest sculpted monument in the cemetery.

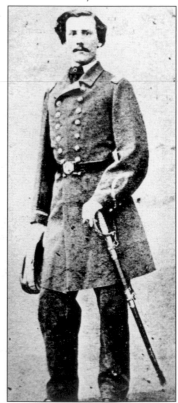

In April 1861, nineteen-year-old William Worley, a miller and farmer by trade, enlisted in the Danville Light Artillery. He married Mary Galveston, age 16, in March 1864 in Pittsylvania County, Virginia. On Sunday, April 2, 1865, about 300 Confederates were stationed at Fort Gregg, along the Boydton Plank Road near Petersburg—not too far from Worley's birthplace in Henry County. They had been ordered to hold the fort to enable the rest of Lee's army to retreat across the Appomattox River. A Union division of 5,000 men attacked the earthen fort and overwhelmed the defenders, who fought to the last man. The mortally wounded Worley was transported to Washington, D.C., where he died from his head injury on April 23, 1865, and was buried the next day in Arlington Cemetery. He is buried near the New South monument. (Library of Congress.)

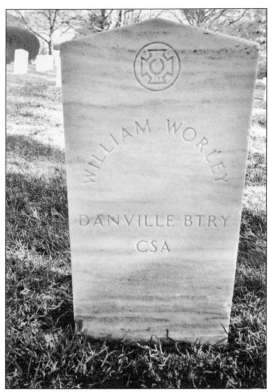

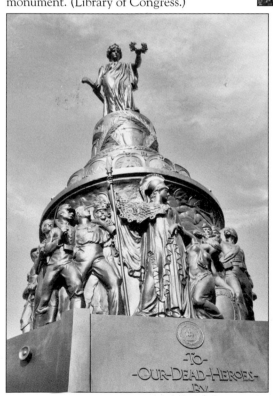

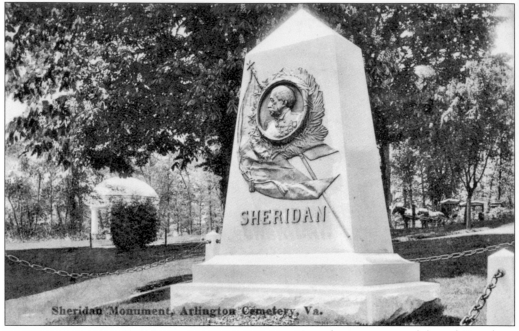

Sheridan Monument, Arlington Cemetery, Va.

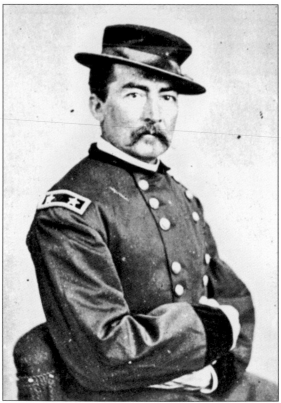

Near the now-removed domed Temple of Fame and the southeast corner of Arlington House is the truncated obelisk of Gen. Philip H. Sheridan. He is one of the three Union generals who won the greatest fame during the Civil War, the other two being Ulysses S. Grant and William T. Sherman. Sheridan's contribution to the Federal war effort was outstanding. He was a division commander at Chickamauga, Georgia, and Chattanooga, Tennessee. In Virginia, from the 1864 Battle of Yellow Tavern to Appomattox, he was the cavalry corps commander of the Army of the Potomac. It was Sheridan's idea to create an independent cavalry corps—one that could quickly strike the enemy and not be slowed down by infantry and artillery. Sheridan's burial in 1888 is significant because he is the highest-ranking officer interred in Arlington in the 19th century. (Library of Congress.)

SHERIDAN

SIX COLUMNS ERECTED IN THE PORTICO OF THE WAR OFFICE, WASHINGTON IN 1818, WERE ON THE DEMOLITION OF THAT BUILDING IN APRIL 1879, TRANSFERRED TO THE GATEWAYS OF THIS ARLINGTON NATIONAL MILITARY CEMETERY.

Sheridan Gate, Arlington Cemetery, Va.

Sheridan's ride on his horse, Rienzi, from Winchester to Cedar Creek, Virginia, on October 19, 1864, to rally his seemingly defeated forces to victory is legendary. Politically it provided Abraham Lincoln a boost in defeating George McClellan for president on November 8, 1864. Sheridan's burial site in front of Arlington House with an impressive monument in prominent view elevated the stature of the cemetery, which had been primarily a potter's field for soldiers of low rank and income. His interment ushered in a decade in which a series of major generals and an admiral followed Sheridan's burial: Gen. George Crook in 1890; Adm. David Porter in 1891; and Generals Montgomery Meigs in 1892, Abner Doubleday in 1893, Stephen Burbridge in 1894, Walter Gresham in 1895, John Gibbon in 1896, John Mason in 1897, William Rosecrans in 1898, and Horatio Wright in 1899.

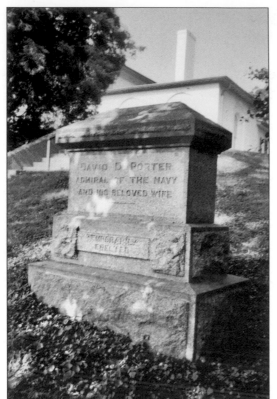

The burial site of Adm. David D. Porter is about 60 feet from Arlington House. During the Civil War, Porter's commands included a mortar fleet at New Orleans composed of the Mississippi River Squadron, which broke through the gauntlet of Confederate batteries at Vicksburg, and the North Atlantic Blockading Squadron, which largely succeeded in the blockade of the 3,000-mile-long coast of the Confederacy. With 59 ships, he culminated his success as a naval commander with the January 15, 1865, assault and capture of Fort Fisher, which protected Wilmington, North Carolina. After the war, he became superintendent of the Naval Academy from 1865 to 1869. Porter's wife of more than 50 years, George Ann Patterson, is buried with him. (U.S. Naval Academy.)

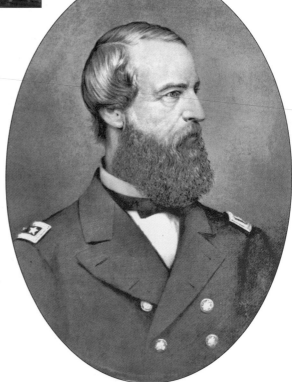

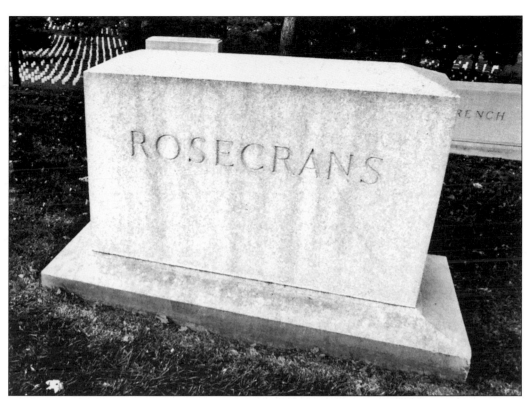

William Rosecrans from Ohio graduated fifth in the 1842 class of the U.S. Military Academy. He spent 10 years in the Engineer Corps and did not participate in the Mexican War. In 1854, he resigned from the army but rejoined after the Civil War began. Rosecrans's career as a brigadier general includes driving Confederate soldiers from western Virginia—leading to the creation of the state of West Virginia, holding on at the Battle of Murfreesboro, Tennessee, and later maneuvering the Confederates out of that state before enduring a major defeat at Chickamauga, Georgia. He died in 1898 in California and on May 17, 1902, was reinterred in Arlington. (Library of Congress.)

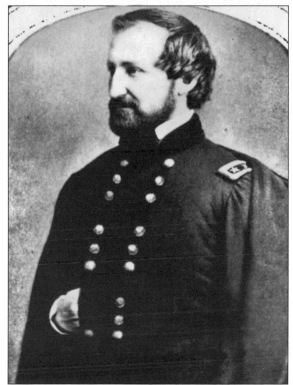

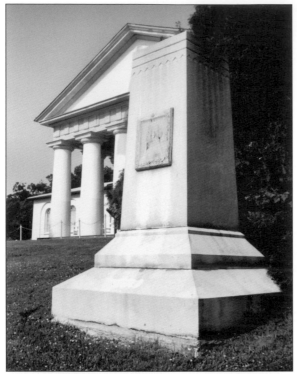

The closest monument to Arlington House is the eight-foot-tall, truncated obelisk of Gen. Horatio G. Wright, which is 45 feet from the mansion's front porch steps. Wright graduated second in the West Point class of 1841. During the Civil War, he participated in battles at First Bull Run, Gettysburg, and the Wilderness. When Gen. John Sedgwick was killed at Spotsylvania on May 9, 1864, by a sharpshooter, Wright replaced him as commander of the VI Corps. He led his troops at Cold Harbor and Petersburg. In July 1864, he directed his corps to Washington to thwart the Confederate attack on Fort Stevens. After the war, Wright oversaw the completion of the Washington Monument—visible across the Potomac River from his burial site. (Library of Congress.)

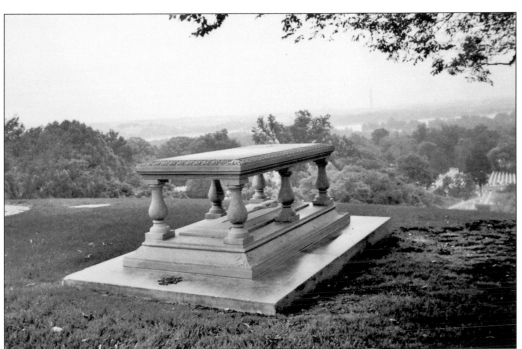

Generals Sheridan and Wright were placed in front of Arlington House facing Washington, D.C., to honor them as defenders of the city during Confederate general Jubal Early's attack on July 12, 1864. Wright's burial in 1899 closed out a decade in which there was an annual interment of a Civil War general or admiral. The name recognition of these high-ranking officers gradually increased the public view of Arlington as a prominent military cemetery. Rank-and-file soldiers who received honors for their valor during the Civil War would soon follow the lead of their generals. In front of the Doric columns of Arlington House is the tomb sculpted by Welles Bosworth for Parisian Peter L'Enfant—whose design of the capital is embossed on the top of the marble shown in this 1940s photograph. It overlooks the city and passageways he designed at George Washington's request.

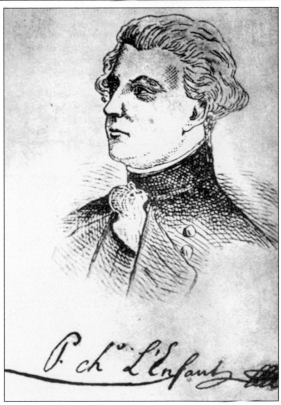

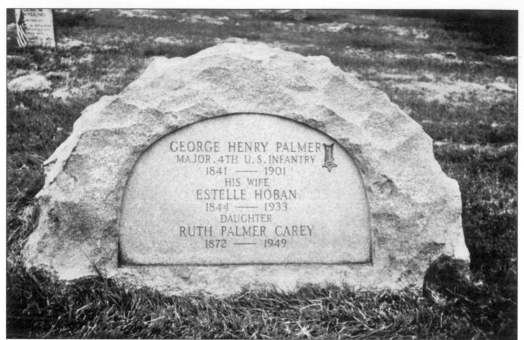

GEORGE HENRY PALMER
MAJOR 4TH U.S. INFANTRY
1841 —— 1901
HIS WIFE
ESTELLE HOBAN
1844 —— 1933
DAUGHTER
RUTH PALMER CAREY
1872 —— 1949

The next sequence in the progression of Arlington National Cemetery's status was the interments of 95 Civil War Medal of Honor recipients. These distinguished awardees selected Arlington for their final resting place. George H. Palmer was awarded the Medal of Honor in the 1861 Battle of Lexington, Missouri, for leading a charge that recaptured a Federal hospital occupied by enemy sharpshooters. Palmer, a native of New York, served in the Illinois cavalry and infantry before joining the regular U.S. Army as a career. He and his wife, Estelle, had two daughters and three sons—two of whom fought in World War I. Palmer died on April 7, 1901. His obituary began, "Death loves a shining mark," and his granite marker is adorned with a bronze replica of the Medal of Honor.

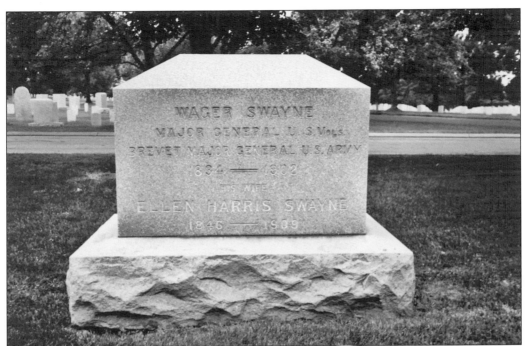

Wager Swayne graduated from Yale University and Cincinnati Law School. Swayne's father, Virginia-born Noah Swayne, was the first of Pres. Abraham Lincoln's five appointments to the U.S. Supreme Court. Native-Ohioan Wager Swayne, at age 27, became lieutenant colonel of the 43rd Ohio Infantry. His Medal of Honor citation indicates he received the medal for "gallantry in restoring order at a critical moment and leading his regiment in a charge" during the October 4, 1862, Union victory at Corinth, Mississippi. During the "March to the Sea" Swayne was struck by an artillery shell fragment at River's Bridge, South Carolina, on February 2, 1865, resulting in the amputation of his right leg. He worked in the Freedman's Bureau until 1870 and then practiced law in New York City, where he died in 1902. Swayne's marker does not acknowledge his Medal of Honor.

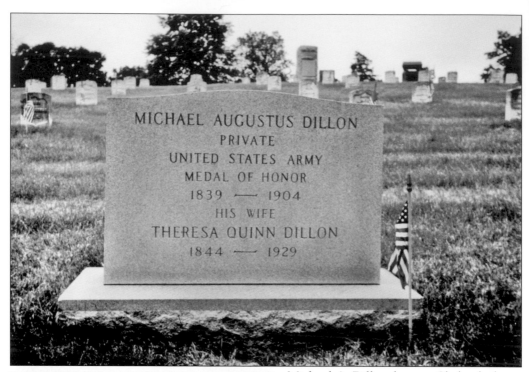

Michael A. Dillon, born at Chelmsford, Massachusetts, in 1839, enlisted in the 2nd New Hampshire Infantry in May 1861. When four Union cannons were captured during the May 5, 1862, Battle of Williamsburg, Virginia, Dillon advanced and urged his comrades to recover the guns. A company lieutenant yelled, "Get down, Dillon, you are drawing the enemy's fire!" Dillon responded, "What in hell are we here for? Come on boys . . . take that battery." Dillon was shot in the leg while rallying the men to recapture the artillery. His 1862 exploits include securing vital information from a reconnaissance at Oak Grove, Virginia, and fighting at the Battle at Second Bull Run, where he was shot in his right lung. Dillon and his wife, Theresa, a native of Ireland, had five daughters: Mabel, Bessie, Rose, Agnes, and Marie. He served as commander of the Medal of Honor Legion.

The 28-year-old James D. Vernay, a lieutenant in the 77th Illinois Infantry, volunteered to command the steamer *Horizon* to transport Union supplies across the Mississippi River at Vicksburg. On April 22, 1863, six transport steamers and 12 barges attempted to run the gauntlet of batteries, which sunk 1 steamer and 6 barges. Adm. David Porter proclaimed "the conduct of the soldiers who manned the transports as among the most heroic of the whole war." The delivery of supplies in the Vicksburg Campaign contributed to the surrender of about 29,000 Confederate troops on July 4, 1863—a major victory—and underscores the importance of supply management. Vernay was born in Lacon, Marshall County, Illinois. His parents were natives of Maryland—a slave state before the Civil War. Buried next to Vernay is his German-born wife, Adelaide.

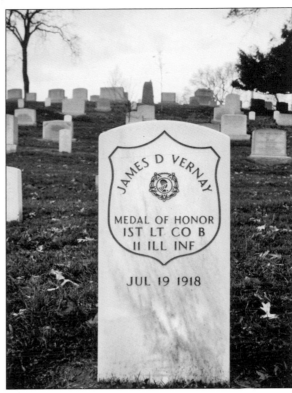

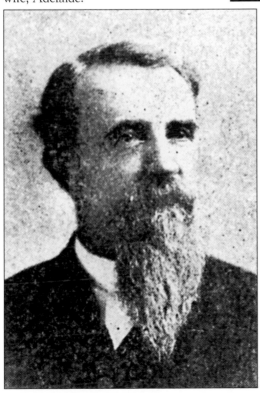

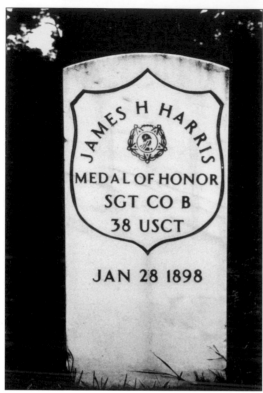

Sgt. James Harris, pictured below, a native of St. Mary's County, Maryland, was bestowed the Medal of Honor for gallantry in the assault at New Market Heights, Virginia. Also leading troops to victory was Milton Holland (pictured on the following page), who was born into slavery in 1844 in Austin, Texas. In the 1850s, he and his two brothers were sold to Byrd Holland, a Texas politician who sent them north to Albany Enterprise Academy in Ohio. In August 1863, Holland enlisted in the 127th Ohio Infantry, which was redesignated as the 5th USCT. Before daybreak on September 29, 1864, Union troops under the command of Maj. Gen. Benjamin Butler positioned themselves for a two-pronged attack on defenses southeast of Richmond, Virginia. (HomeOfHeroes.com.)

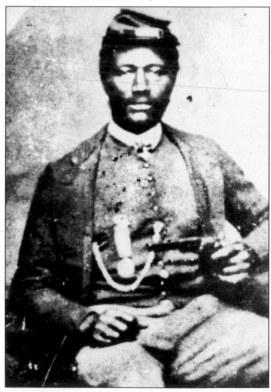

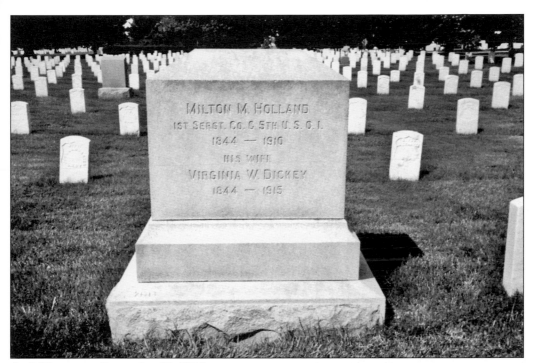

At 8:00 a.m. on September 29, 1864, four black regiments advanced across an open field 800 yards from Confederate works on the New Market Road. Two rows of abatis obstructed the approach. Heavy losses from rifle fire and the abatis stalled the Union assault 30 yards from the entrenched Confederate line. Milton Holland (right), Harris, and three other black sergeants rose from the ranks, took command of their companies, and assisted in getting the brigade in motion. While capturing the position, Holland's regiment bore the brunt of the attack, suffering 213 soldiers killed and wounded. General Butler said of Holland, "Had it been within my power I would have conferred upon him in view of it, a brigadier-generalship for gallantry in the field." After the war, Holland founded Alpha Insurance—one of the first black insurance companies. (HomeOfHeroes.com.)

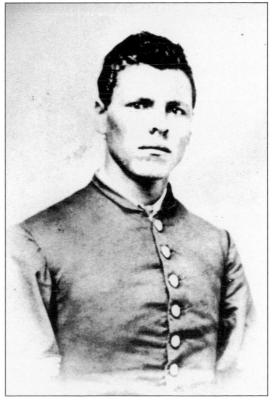

45

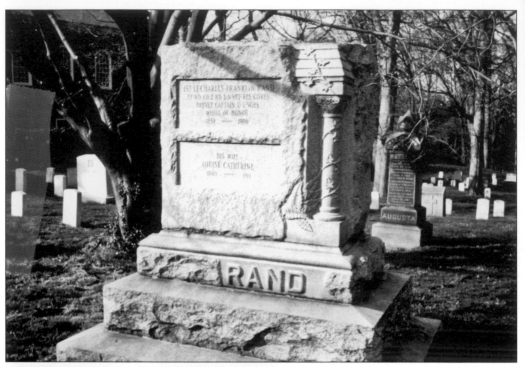

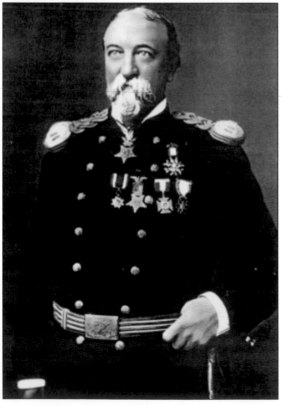

Charles Rand was awarded the Medal of Honor for his determination to remain and engage the enemy in the July 1861 skirmish at Blackburn's Ford, Virginia. A native of Batavia, New York, Rand was a 22-year-old printer until President Lincoln asked for volunteers. A U.S. Senate report states that "it is claimed that Rand was the first man to enlist" for Federal service as opposed to militia duty. In the 1862 Battle at Gaines's Mill, Virginia, Rand was wounded and discharged on a disability. He earned a medical degree from Georgetown University in 1873. In an unusual ceremony, the Medal of Honor Legion dedicated Rand's monument in Arlington Cemetery in October 1907 with Rand alive and present. He practiced medicine in D.C. until his death in 1908. His first wife, Gabriella, was a nurse. (HomeOfHeroes.com.)

John Cook was a diminutive four feet, nine inches tall upon his enlistment at the age of 14 on June 7, 1861. He was born on August 10, 1846, in Cincinnati, Ohio. Before the war, he was a laborer. At the Battle of Antietam, Maryland, the young bugler was awarded the Medal of Honor for volunteering to serve as a cannoneer after observing that nearly all of the battery cannoneers of the Fourth U.S. Artillery were killed or wounded. When his term expired on June 7, 1864, Cook reenlisted as a landsman for the U.S. Navy. The blue-eyed veteran was now over five feet, six inches tall when he boarded the Union gunboat *Peosta* in September 1864. After the war, Cook was employed as a court police officer in Cincinnati. He married Isabella McBride in 1870, and they had three children: John, Rebecca, and Margarette. (HomeOfHeroes.com.)

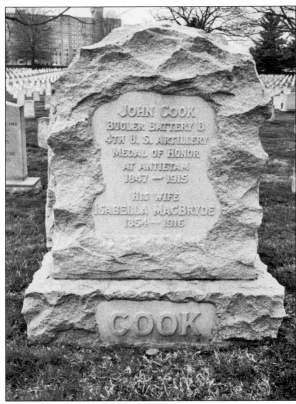

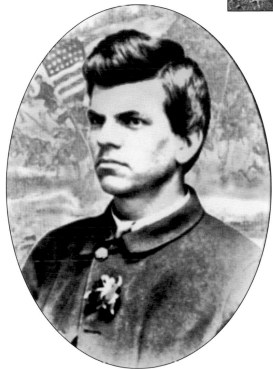

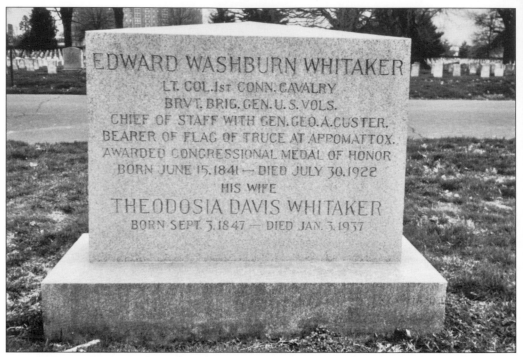

Edward Whitaker was born in Killingly, Connecticut. His parents, George and Mary Whitaker, had 16 children. Edward and three of his eight brothers enlisted in Federal units when the war began. Edward Whitaker was awarded the Medal of Honor for his conduct on June 29, 1864, at the Battle of Reams Station, Virginia. He is cited for "voluntarily carrying dispatched from the commanding officer to General Meade, forcing his way with a single troop of cavalry, through an infantry division of the enemy, though he lost half his escort." Whitaker was made a brevet brigadier general on March 13, 1865, and bore the truce flag at Appomattox to initiate the parley between Grant and Lee that would ultimately end a war in which over 620,000 persons perished from wounds or disease.

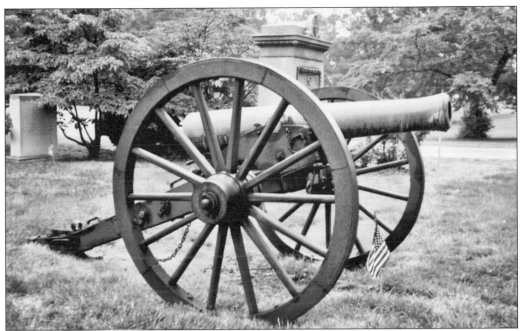

An authentic 12-pound-shot Napoleon cannon manufactured in 1862 is over the interment site of Wallace F. Randolph, an artillery lieutenant in the Civil War. He is reported as saying that his life had been spent behind cannons; therefore, he would not object to spending eternity beneath one. The placement of a 1,239-pound cannon in Arlington Cemetery led to regulation changes in 1947. Below, the bronze sculpture atop the sarcophagus of John Meigs portrays the manner in which the son of Gen. Montgomery Meigs was found in 1864 after being shot on the Swift Gap Road in Virginia. Montgomery Meigs died in 1892 and is buried near his son, John. General Meigs was an efficient quartermaster general during the Civil War. He later supervised the expansion of the wings and dome of the U.S. Capitol, but he is best known for establishing a national cemetery at Arlington.

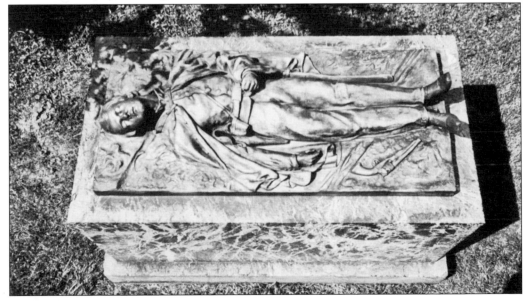

Near the Old Amphitheater is a bronze equestrian monument of Gen. Phil Kearny presented by the State of New Jersey. Sculptor Edward C. Potter depicts Kearny, an excellent rider, without a left arm since it had been amputated after his wound in the Battle of Churubusco in the Mexican War. Kearny knew Robert E. Lee from the military and had attended parties at Arlington House before the Civil War. Kearny, born in New York City, commanded the 1st New Jersey Brigade. He was killed at the Battle of Chantilly or Ox Hill in Fairfax County on September 1, 1862, and was buried at Trinity Churchyard in New York City. As the stature of Arlington Cemetery began to rise, veterans of his former brigade petitioned the Kearny family requesting his reinterment in Arlington. They consented, and hundreds attended the November 11, 1914, dedication. (Library of Congress.)

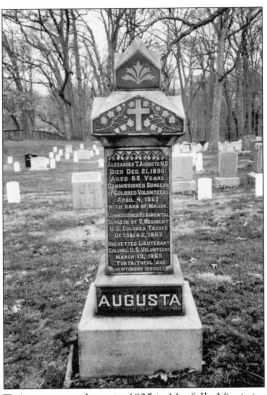

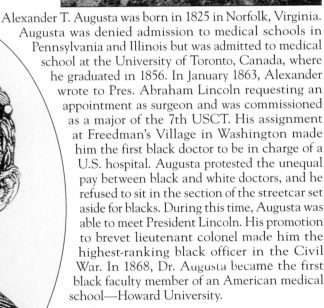

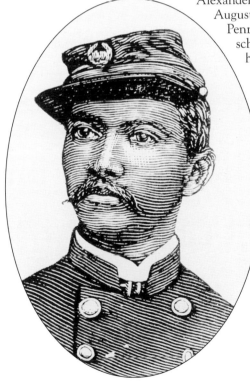

Alexander T. Augusta was born in 1825 in Norfolk, Virginia. Augusta was denied admission to medical schools in Pennsylvania and Illinois but was admitted to medical school at the University of Toronto, Canada, where he graduated in 1856. In January 1863, Alexander wrote to Pres. Abraham Lincoln requesting an appointment as surgeon and was commissioned as a major of the 7th USCT. His assignment at Freedman's Village in Washington made him the first black doctor to be in charge of a U.S. hospital. Augusta protested the unequal pay between black and white doctors, and he refused to sit in the section of the streetcar set aside for blacks. During this time, Augusta was able to meet President Lincoln. His promotion to brevet lieutenant colonel made him the highest-ranking black officer in the Civil War. In 1868, Dr. Augusta became the first black faculty member of an American medical school—Howard University.

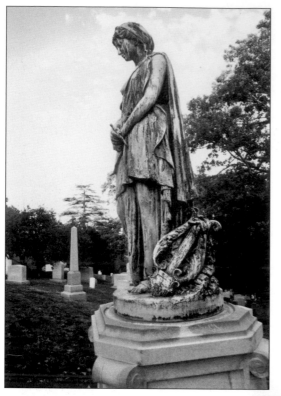

Vinnie Ream was the sculptor of statues of Abraham Lincoln and Native American Sequoya—each of which stand in the rotunda of the U.S. Capitol. Lincoln posed on various days for sculpting sessions with the 17-year-old pioneering lady sculptor—including the morning of the day he was shot—April 14, 1865. Her commission to sculpt Lincoln made her the first woman, and the youngest artist, to receive a U.S. government commission for a statue. Upon its unveiling in 1871, Wisconsin senator Matthew Carpenter reacted by stating "it is Abraham Lincoln all over." She then received a number of commissions, including the Farragut Monument of Adm. David Farragut at Farragut Square in D.C. Ream died on November 20, 1914, and is buried next to her husband, Brig. Gen. Richard Hoxie. The grave site of Vinnie Ream includes a bronze reproduction of her sculpture of Sappho the poetess. It stands atop a pedestal containing a bas-relief of her. (Library of Congress.)

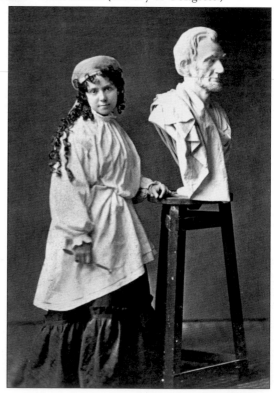

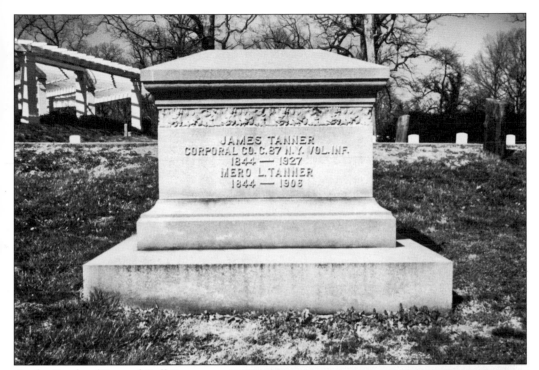

At the Battle of Second Bull Run on August 30, 1862, James Tanner of Richmondville, New York, was struck by an artillery shell, and both his legs were amputated. On April 14, 1865, he was brought to Abraham Lincoln's deathbed at the Peterson House to take dictation of Secretary of War Edwin Stanton's orders. Admitted to practice law in 1869, he was an advocate for disabled veterans. Tanner was elected in 1905 as commander of the Grand Army of the Republic—a Civil War veterans organization and potent lobbying group. Nicknamed "Corporal Tanner," he spoke at or was involved with events ranging from the dedication of the Confederate Section in Arlington Cemetery to the 1922 tribute of the Ulysses S. Grant Memorial in Washington, D.C. He and his wife, Mero, raised four children. They are buried opposite the Old Amphitheatre where Tanner eulogized the dead on various Memorial Days.

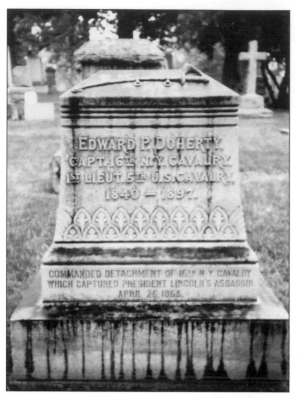

Canadian-born Edward Doherty became famous for tracking the assassin of Pres. Abraham Lincoln. On April 26, 1864—11 days after Lincoln's demise—Doherty and his squad of 25 men of the 16th New York Cavalry captured John Wilkes Booth and conspirator Davy Herold near Port Conway, Virginia. Doherty's men located them in a barn on the farm of Richard H. Garrett. According to Doherty, he ordered their surrender, and Booth, who held a gun, replied, "I may be taken by my friends, but not my foes." Herold surrendered, but Booth was shot and died seven hours later. Congress awarded Doherty $7,500 for his handling of the search and for his personal seizure of Herold. Doherty was active in veteran's affairs and worked for the Department of Public Works in New York City. (National Archives.)

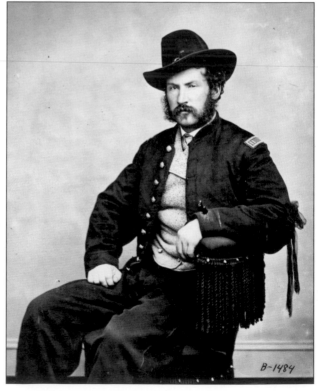

Keystone View Company Publishers

Manufacturers COPYRIGHTED MADE IN U.S.A.

Meadville, Pa., New York, N. Y., Chicago, Ill., London, England.

32258 Distant Washington from the Heights of Arlington National Cemetery, Va.

August Kautz, a native of Baden, Germany, was twice wounded in the struggles with American Indians. He commanded a United States Colored Troops corps that triumphantly entered the Confederate capital of Richmond on April 3, 1865. Kautz served on the military commission, which determined the fate of the Lincoln conspirators, and is pictured standing between two officers. He died in Seattle, Washington, and was returned to Arlington for interment. In the c. 1925 photograph above, the granite marker of Kautz is to the left of the cross monument of Guy V. Henry—a Medal of Honor recipient for his action at the June 1, 1864, Battle of Cold Harbor, Virginia, Gen. Ulysses S. Grant's worst defeat. Next to Kautz is the obelisk of Gen. John A. Rawlins—chief of staff for General Grant during the war. In the background is the Lincoln Memorial and the Washington Monument—a 555-foot obelisk.

While the Civil War was in progress, President Lincoln's eldest son, Robert, graduated from Harvard College. At President Lincoln's request, Robert was commissioned as a captain and joined Gen. Ulysses S. Grant near Petersburg, Virginia. He was present at Appomattox for the surrender of Confederate forces by Gen. Robert E. Lee. Upon his return to Washington, D.C., Abraham Lincoln invited Robert to accompany him and Mary Lincoln to Ford's Theatre. Robert decided to visit friends and during the night learned of his father being shot. He was present with his mother at the Peterson House when President Lincoln died on April 15, 1865. Robert became a lawyer and served as Secretary of War and as president of the Pullman Company. His sarcophagus faces east in view of the Lincoln Memorial—where he attended its dedication with Chief Justice William H. Taft (left) and Pres. Warren G. Harding (center) on May 30, 1922 (below). (Library of Congress.)

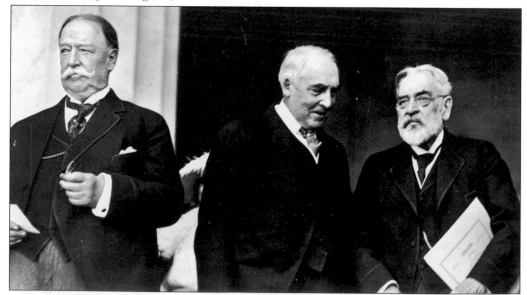

Two

REVOLUTIONARY WAR SOLDIERS THROUGH THE SPANISH-AMERICAN WAR

John Green is one of 11 Revolutionary War soldiers reinterred in Arlington National Cemetery. He became captain of the 1st Virginia Regiment on September 4, 1775, and was later commissioned as a colonel and alternately led the 6th Virginia and 10th Virginia Regiments. Green was present at Valley Forge, Pennsylvania, in 1777–1778 and saw service in Rhode Island, New Jersey, and Virginia. In North Carolina, he was in the March 15, 1781, Battle of Guilford Courthouse. Green was a founding member of the Order of Cincinnatus—a hereditary group formed by officers of the war.

Col. William Russell was a member of the May 17, 1776, Virginia Convention and at various times commanded the 5th, 6th, 10th, 11th, and 13th Virginia Regiments. He and Col. John Green were both Masons, each receiving their initiation at Williamsburg, Virginia. The Masonic impact cannot be overstated as 40 percent of George Washington's officers belonged to this fraternity, where members believe in God and learn moral lessons through a series of "degrees." Russell endured the winter at Valley Forge. He was captured during the fall of 1780 in Charleston, South Carolina. Returning to Fincastle, Virginia, he served as a senator to the Virginia General Assembly—the oldest representative body in the western hemisphere. Russell County, Virginia, is named after him.

Lt. Donald McIntosh served under the command of Gen. George Custer. A native of Quebec, Canada, he was with the battalion of Maj. Marcus Reno on June 25, 1876, as they moved toward Little Big Horn Valley. According to Reno, he estimated that his troops were outnumbered five to one and that "the very earth seemed to grow Indians." Several 7th Cavalrymen were killed during a horseback charge toward the Sioux early in the battle. Among them was McIntosh, who was reburied in Arlington in 1909 by his wife, Molly, who died a year later and is interred with him.

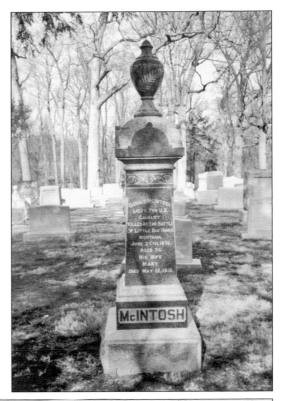

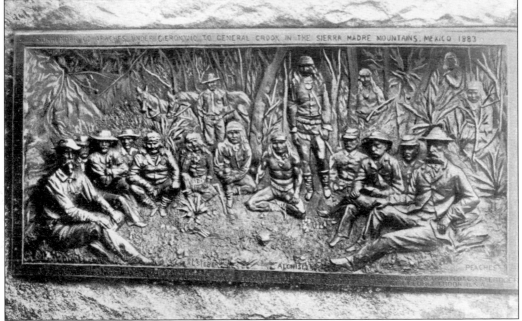

Gen. George Crook was an effective cavalry commander in the Civil War. Yet his most noteworthy deed appears to be his 1883 capture of Apache Chief Geronimo, which is depicted in his marker's bronze bas-relief shown in this 1923 photograph. Crook was later critical of what he opined was the federal government's poor treatment of Native Americans.

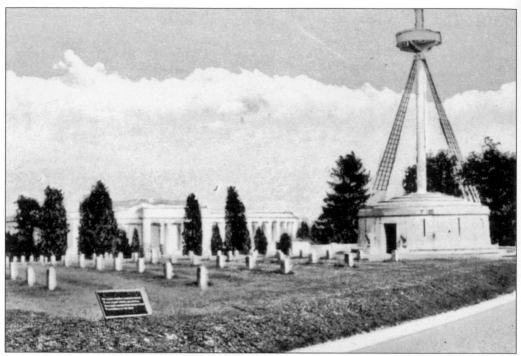

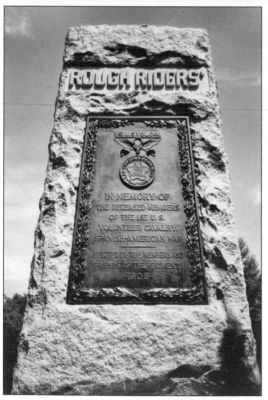

The battleship *Maine* was in Havana Harbor, Cuba, when it exploded on February 15, 1898. Two hundred sixty men died out of a crew of 355. This event precipitated the Spanish-American War. In 1899, members of the crew submerged in the *Maine* were disinterred and buried in Arlington—the first time U.S. servicemen who were killed abroad were returned to Arlington. Presiding over those burials was Adm. George Dewey who had directed the naval battle against Spain at Manila Bay. The main mast of the *Maine* was recovered and brought to Arlington in 1912 to become part of the memorial designed by architect Nathan Wyeth and shown above in the 1923 photograph. The Rough Riders Memorial (left) honors the First U.S. Volunteer Cavalry. The memorial, dedicated in 1906, names the battles that the unit fought in—Las Guasimas, Santiago, and, most notably, San Juan Hill.

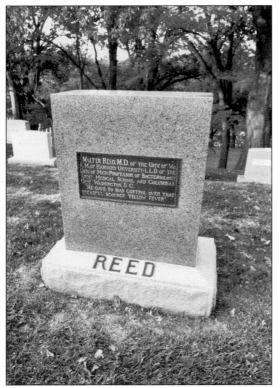

Dr. Walter Reed was the youngest of five siblings and son of a Methodist preacher. At age 18, he graduated from the medical courses of the University of Virginia. He then attended Bellevue Medical School and worked at hospitals in New York. Reed's experiences led him to publish "The Contagiousness of Erysipelas" about an infection of the skin caused by bacteria. He then married Emilie Lawrence and entered the U.S. Army to become a research scientist. He studied and taught bacteriology and pathology as the medical community was accepting the germ theory of infectious disease. In 1900, Reed was appointed to study the spread of illnesses in Cuba. In his research, some of which was conducted on human volunteers, Dr. Reed proved that yellow fever was transmitted by mosquitoes, thus making it possible to combat this deadly disease. (Library of Congress.)

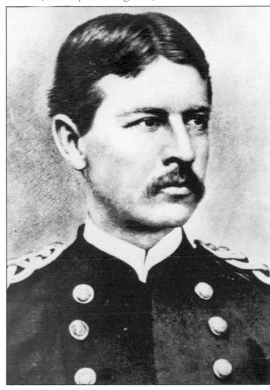

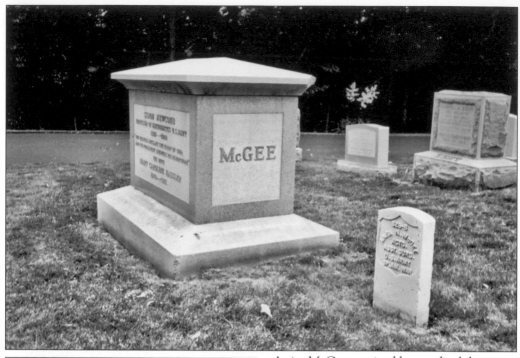

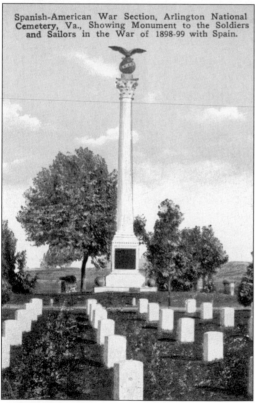

Anita McGee received her medical degree in 1892 from George Washington University. In 1898, she advocated for legislation that created the Army Nurse Corps. The Army Medical Department eventually welcomed her corps as they were not equipped to adequately care for the sick and wounded of the Spanish-American War. The 1917 photograph at left shows fatalities from that war interred in Arlington. McGee mobilized a diverse treatment team that included nuns, African Americans, and Native Americans. She and other American nurses traveled to Japan in 1904 to treat casualties in the Russo-Japanese War. Of her benevolent venture, Dr. McGee wrote that "had we been princesses, the hurrahs of the crowd could not have been louder. . . . To the Japanese we were personal representatives, not of a government, but of a nation, and that nation the greatest, and to them the most friendly on earth."

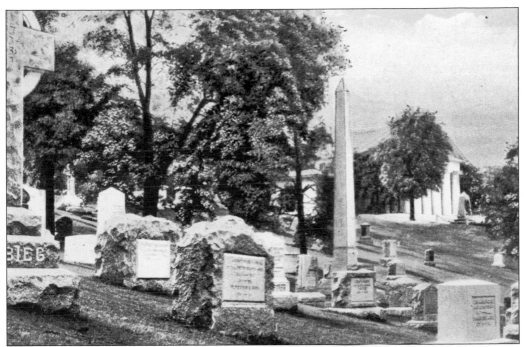

One of the tallest monuments in the cemetery, seen in the above 1920s photograph, is the 45-foot-tall obelisk of Gen. Joe Wheeler. During the Civil War, he was a Confederate cavalry officer who fought in the war's western theater. Yet Wheeler was commissioned as a United States general in the 1898 Spanish-American War. His command of U.S. troops in Cuba and the joint effort of Northern and Southern states in confronting a common enemy were important factors in reuniting the nation 33 years after the Civil War. The 8.5-foot Nurses Memorial statue (right) overlooks a section in which numerous nurses have been interred starting with those who served during the Spanish-American War. Sculptor Frances Rich's marble nurse was unveiled in 1938.

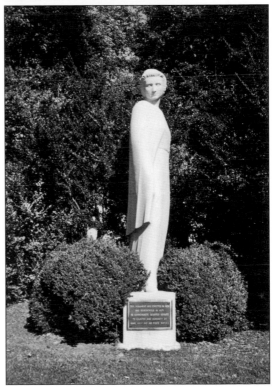

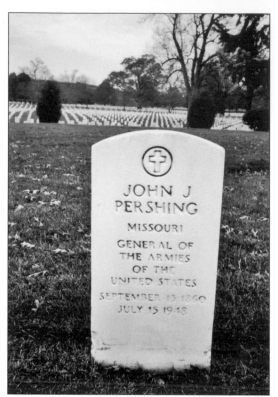

John J. Pershing, while cadet captain at West Point, led the honor guard for the funeral of Pres. Ulysses S. Grant. He was awarded a Silver Star for his conduct in the Spanish-American War in Cuba. In 1917, Pershing commanded the American Expeditionary Force—over two million soldiers. One of his assistants was George C. Marshall, pictured below on the left with Pershing awarding medals. In his autobiography, *My Experiences in the World War,* Pershing describes the Meuse-Argonne offensive as 47 days of a "persistent struggle with the enemy to . . . terminate the war then and there in a victorious manner." The native of Laclede, Missouri, was so successful that he was promoted to general of the armies—a rank shared only by George Washington. Yet Pershing desired a simple headstone and is buried not in the officers section of the cemetery but near his soldiers. (George C. Marshall Foundation.)

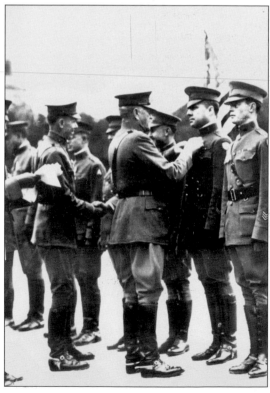

Three

AN ELEVATION
OF STATUS:
Arlington National Cemetery
in the 20th Century

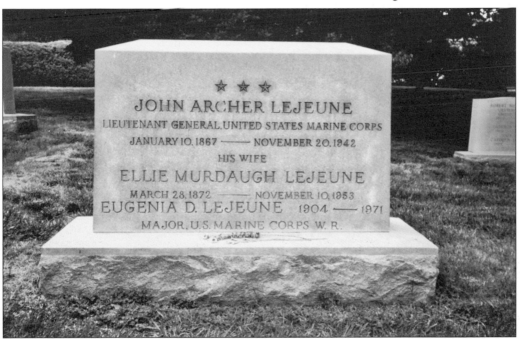

Gen. John Lejeune, a native of Pointe Coupee, Louisiana, saw action in the Spanish-American War and led the 4th Marine Brigade in the 1918 St. Mihiel and Meuse-Argonne offensives in France. A Naval Academy graduate, he was highly decorated for his service in World War I: the Legion of Honor and Croix de Guerre from the French, and Distinguished Service Medals from the U.S. Army and Navy, none of which appear on his marker. After the war, Lejeune served as commandant of the Marine Corps and then superintendent of the Virginia Military Institute.

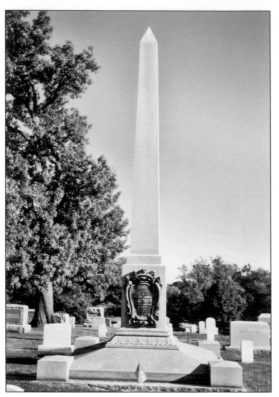

In 1908, the U.S. Army was finally interested in buying a plane that could travel a distance of 125 miles at 40 miles per hour and that could seat two persons. While Wilbur was in France, Orville Wright began flights on September 3, 1908, over the parade ground at Fort Myer, adjacent to Arlington Cemetery. Within two weeks, Orville had conducted 13 flights—two of which included army officers as passengers. On September 17, Orville permitted Lt. Thomas Selfridge on board. After three minutes of flight, the propeller broke and the plane made of wood, canvas, and wire crashed—killing Selfridge and injuring Wright. A native of San Francisco, Selfridge became the world's first air fatality from a plane crash and was buried in Arlington under a tall obelisk marker. In World War I, planes were being used for combat and for reconnaissance. One week before the armistice, 23-year-old Clinton Madison (below) of the Army Air Service was killed.

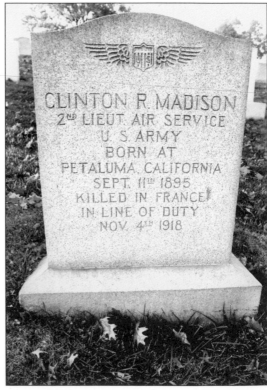

John Pruitt, born in Arkansas, enlisted for World War I while in Arizona. On October 3, 1918, a morning attack was planned at Blanc Mont Ridge—a summit heavily fortified by two German divisions. Four regiments of U.S. Marines successfully advanced up the long slopes and then fought off German counterattacks. According to Medal of Honor citations, Corporal Pruitt was responsible for single-handedly "killing two of the enemy" and capturing two-machine gun positions along with 40 prisoners. The Germans had held this position on French soil for nearly four years and had previously repulsed numerous Allied assaults. The ridge was captured at a cost of 7,800 Americans killed and wounded. Pruitt was among these staggering casualties— killed by shell fire while continuing to engage the enemy. (HomeOfHeroes.com.)

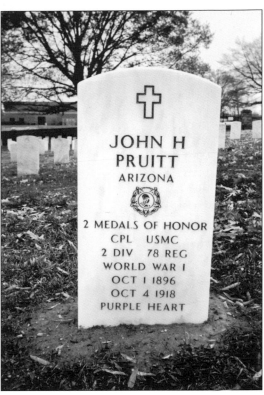

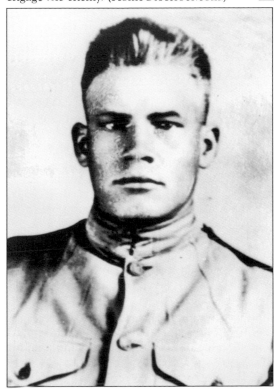

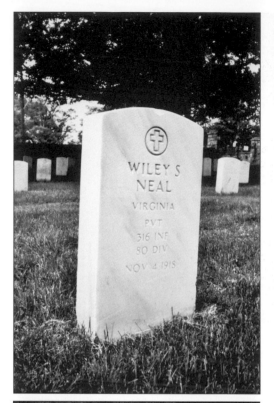

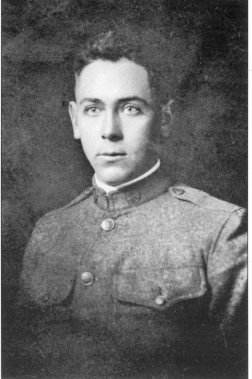

The 13-foot marble Argonne Cross is a memorial to "our men in France 1917–1918," many of whom were casualties in the Argonne Forest region of France in World War I. On September 26, 1918, the Allies began an offensive that would end the war in seven weeks. Wiley Neal, age 23, of Jeffersonville, Tazewell County, Virginia, was in the 80th Division of the American Expeditionary Force. He was killed by an artillery shell in the Argonne Forest, near Buzancy, France, in the last week of the war. Wiley's Methodist family consisted of his parents, John A. Neal (a farmer) and Mary Elizabeth; his younger sister, Leala; and older siblings Joseph (a salesman), Robert (a lumberman), Pearl (a private school teacher), James, and Edward (home farm laborers). (Tazewell County Virginia Public Library.)

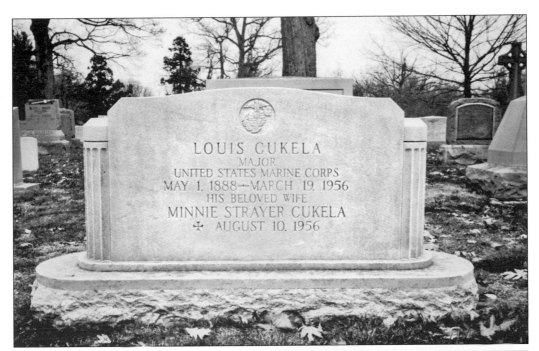

Louis Cukela, a native of Sabenes, Austria, immigrated to the United States in 1913. Cukela is a double recipient of the Medal of Honor as he received the medal from the army and from the navy for the same action. While serving with the 66th Company of the Marines 5th Regiment, his unit engaged German infantry on July 18, 1918, near Villers-Cotterets, France. While under fire, Cukela "succeeded in getting behind the enemy position and rushed a machinegun emplacement, killing or driving off the crew with his bayonet. With German hand grenades he then bombed out the remaining portion of the strong point" and took four prisoners. Cukela was twice wounded in battle, at Jaulny, France, on September 16, 1918, during fighting at St. Mihiel and at Champagne. He married Minnie Strayer of Miflintown, Pennsylvania, on December 22, 1923. (HomeOfHeroes.com.)

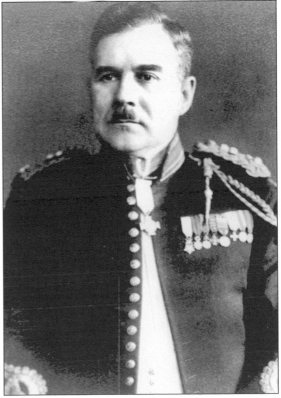

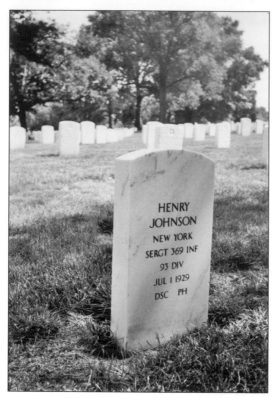

Henry Lincoln Johnson was a railroad porter at Albany Union Station when he enlisted in 1917 into the all-black 369th Infantry, which was assigned to the French Army. On the night of May 14, 1918, in the Argonne Forest, a German raiding party of 24–30 men approached Johnson and Needham Roberts, who were on double sentry. Both men were wounded, and Roberts was seized as a prisoner. Johnson, using his bolo knife and his rifle as a club after it had jammed, fought off the attackers—killing four and wounding eight. Despite 21 wounds, he succeeded in rescuing Roberts. He retuned to his wife, Minnie, and New York City with a hero's welcome. He is pictured in the c. 1940s sketch below. France awarded Johnson the Croix de Guerre—their highest honor. He was awarded the Distinguished Service Cross in 2003.

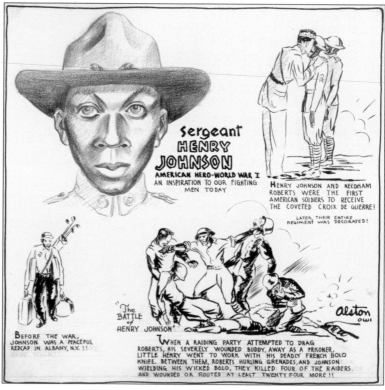

Sgt. Edward F. Younger of Cook County, Illinois, fought at Chateau-Thierry, St. Mihiel, the Somme offensive, and the Meuse-Argonne offensive. Wounded in two battles, Younger received the Distinguished Service Cross—the second highest award for valor. He was granted the honor of selecting from four World War I unidentified U.S. soldiers killed in battle which one was to become the Unknown Soldier for interment at Arlington National Cemetery. On October 24, 1921, four coffins—one each from four separate military cemeteries in France—were placed in a chapel in France. Younger was directed to select the unknown soldier by his placement of a bouquet of roses. According to the veteran sergeant, "I walked around the coffins three times, then . . . I placed the roses." He worked in Chicago after the war as a chauffeur and at the U.S. Post Office. Younger's wife, Agnes, died just after he passed away. They were survived by their son, Jack.

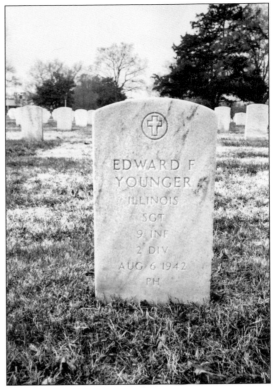

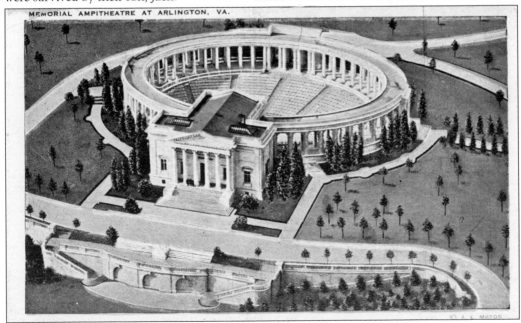

MEMORIAL AMPITHEATRE AT ARLINGTON, VA.

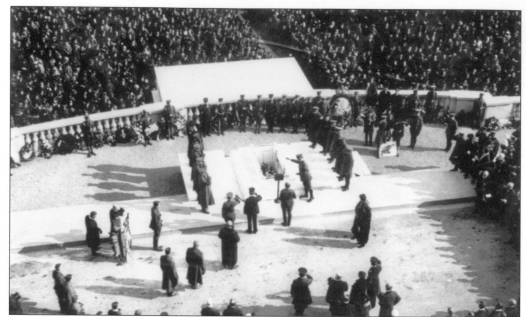

The unknown soldier selected by Sgt. Edward Younger was shipped from France to Washington D.C. This World War I soldier would lie in state at the U.S. Capitol from November 9–11, 1921. On Armistice Day, November 11 (now known as Veterans Day) the unknown soldier was interred in Arlington before a throng of 100,000 assembled on all sides of the new Amphitheatre. According to the *New York Times*, "when the President [Harding] concluded his speech with the Lord's Prayer the crowds, head bared, repeated it. They sang 'Nearer My God to Thee.' . . . stood silent for two minutes at noon. . . . Then a minute later 'America' was sung." Pictured below is President Coolidge speaking at a 1924 service at the Amphitheatre. This further solidified the presidential tradition of speaking at Arlington National Cemetery on occasions such as Memorial Day and Veteran's Day. (Library of Congress.)

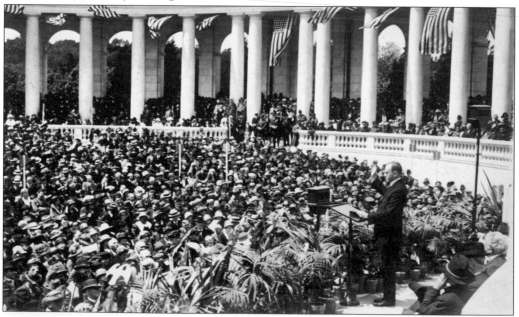

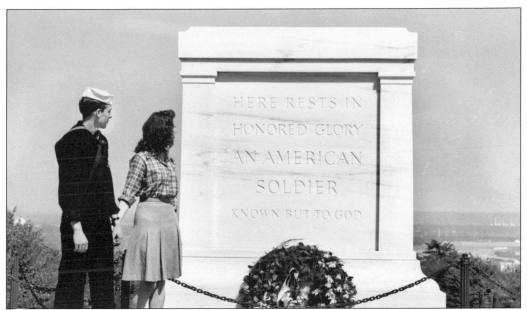

A 50-ton, white marble sarcophagus designed by architect Lorimer Rich was placed above the grave of the Unknown Soldier of World War I. On the panel facing east, Thomas H. Jones sculpted three figures representing peace, victory, and valor. In the May 1943 photograph, a navy man and his girlfriend read the inscription on the west side. On Memorial Day 1958, Pres. Dwight D. Eisenhower presided over the ceremony of the burial of Unknown Soldiers from World War II (left crypt) and the Korean War (right or south crypt). An unknown soldier representing the war in Vietnam was placed in a crypt beneath the middle, white slab on Memorial Day 1984. However, DNA testing later identified that soldier as Michael J. Blassie of the U.S. Air Force. In 1998, he was disinterred at his family's request and buried in Missouri. The center crypt, while remaining empty, symbolizes the Vietnam sacrifice and was rededicated to "America's Missing Servicemen." (Library of Congress.)

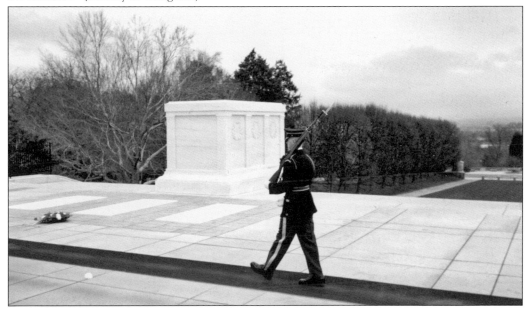

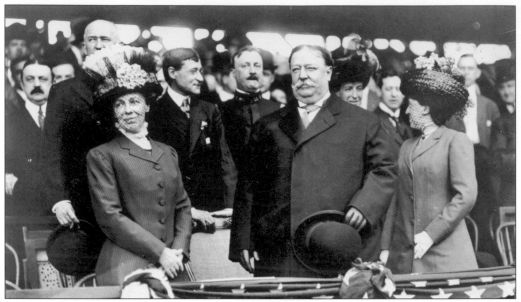

William H. Taft, born in Cincinnati, Ohio, graduated from Yale and then studied law at Cincinnati Law School. Upon admission to the Ohio bar, Taft prosecuted cases in Hamilton County for two years, served as collector of revenue, and then practiced law in a partnership. In 1888, Taft was elected as a judge on the Cincinnati Superior Court—the only election that he won prior to his 1908 presidential victory over William Jennings Bryan. He was appointed as solicitor general in 1890 and from 1892 to 1900 served as a federal judge. He became governor of the Philippines and in 1904 was appointed by Pres. Theodore Roosevelt as secretary of war. In 1909, Taft was sworn in as president. In the above photograph, Taft began a presidential tradition of making the first ceremonial throw on baseball's opening day—April 14, 1909, for Washington's 3-0 victory over the Philadelphia Athletics. Pictured below is a Boy Scout tribute in 1930 showing Taft's original headstone. (Library of Congress.)

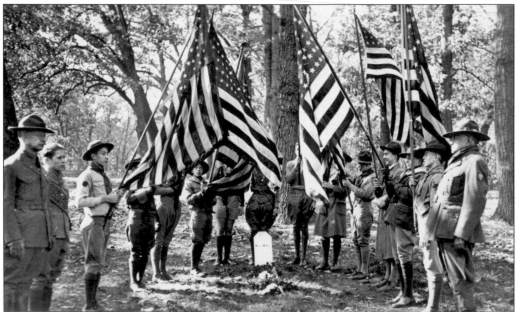

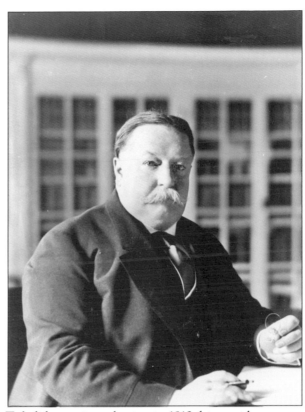

Although Taft did not win reelection in 1912, his presidency and previous administrator duties prepared him for his service as chief justice of the Supreme Court, to which Pres. Warren G. Harding appointed him in 1921. Taft wrote opinions in 200 court cases, yet his advocacy of the 1925 Judges' Bill ranks high among his accomplishments. The legislation brought a unification of the federal judiciary and created management tools such as the Conference of Senior Circuit Judges. Taft also secured from Congress a commitment for a new Supreme Court building. His wife, Helen "Nellie" Taft, arranged for cherry trees from Japan to be placed in Washington. She was extremely interested in politics and guided Taft's career. Their children were high achievers: Robert, U.S. senator; Helen, dean at Bryn Mawr College; and Charles, mayor of Cincinnati. Taft's regulation headstone was replaced with a monument created by sculptor James E. Fraser. (Library of Congress.)

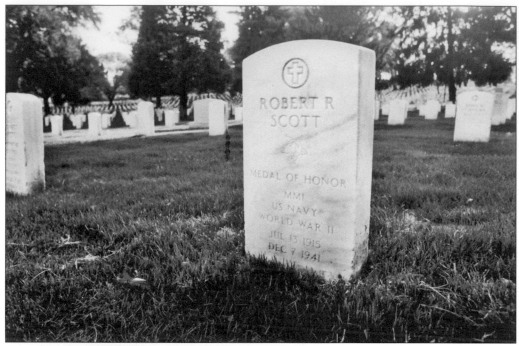

During the Japanese surprise attack on the U.S. Naval fleet at Pearl Harbor, Machinist's Mate First Class Robert Scott manned his station aboard the USS *California*. He was posthumously awarded the Medal of Honor for his conduct on December 7, 1941. As Scott's compartment began to flood as a result of a torpedo hit, he continued to work his air compressor and refused to abandon the ship, stating words to the effect that "this is my station and I will stay and give them air as long as the guns are going." Scott, a 26-year-old native of Massilon, Ohio, who attended Ohio State University, died in the attack that forced the United States into World War II. Although no U.S. carriers were sunk, 8 battleships and 188 planes were damaged or destroyed. Scott was among 2,403 Americans killed in the Japanese plan to neutralize U.S. Naval strength in the Pacific. (HomeOfHeroes.com.)

Henry Elrod, a native of Rebecca, Turner County, Georgia, attended college at Georgia and Yale before enlisting in the U.S. Marine Corps in 1927. At Wake Island on December 9 and 12, 1941, pilot Elrod shot down two planes and sunk the Japanese destroyer *Kisaragi*—the first major warship ever to be sunk by small-caliber bombs delivered from a fighter plane. After his aircraft was disabled by enemy fire, 36-year-old Captain Elrod took command of a section of the Wake Island defense and helped repulse enemy ground attacks until he fell mortally wounded on December 23, 1941. Posthumously he was promoted to major and was the first aviator awarded the Medal of Honor. According to Elrod's citation, it was his "superb skill as a pilot, daring leadership and unswerving devotion to duty [which] distinguished him among the defenders of Wake Island." (HomeOfHeroes.com.)

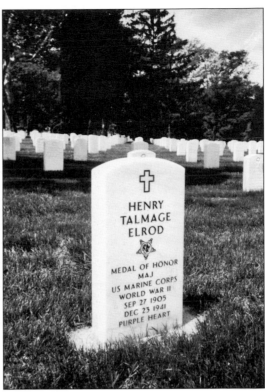

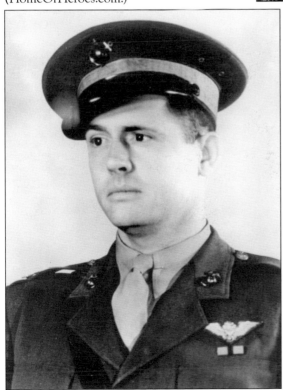

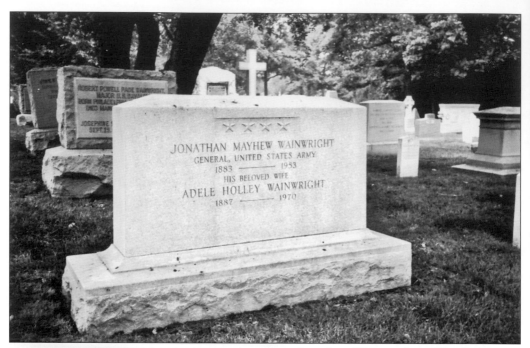

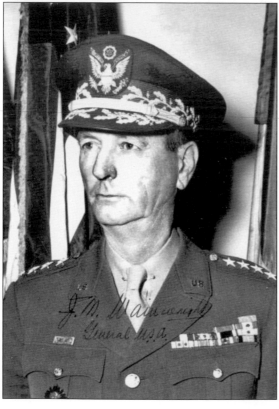

Jonathan Wainwright, a West Point graduate, was in command of U.S. and Filipino forces on the Philippine Islands at the outset of World War II. Low on supplies and vastly outnumbered, he was compelled to surrender to the Japanese at Corregidor Island in May 1942—one of the U.S. military's largest troop surrenders. He and his men were forced to walk in what was known as the Bataan Death March, in which an estimated 15,000 prisoners succumbed to Japanese abuse. During captivity, Wainwright, a native of the state of Washington, was beaten and humiliated by Japanese guards. Liberated in August 1945, he was on board the USS *Missouri* to witness the surrender of General Yamashita on September 2, 1945. According to his Medal of Honor citation, Wainwright was presented the Medal of Honor 17 days later for his "intrepid and determined leadership against greatly superior enemy forces" during fighting in the Philippines from March 12 to May 7, 1942. (HomeOfHeroes.com.)

James Doolittle was a gunnery and flight instructor in the Army Signal Corps in World War I. After the war, he studied aeronautical engineering and graduated from the Massachusetts Institute of Technology with a master's and doctorate degree. On April 18, 1942, taking off from the carrier USS *Hornet*, Doolittle led 16 B-25 bombers on a daring raid of four Japanese cities, including Tokyo. The successful raid on the Japanese homeland four months after Pearl Harbor uplifted American morale. It also sent a message to the world that the United States was going to fight back. Doolittle (below, standing in the left foreground) was awarded the Medal of Honor for leading the dangerous one-way mission—there was insufficient fuel to return to the carrier, resulting in the bail out of the flyers in China. A native of Alameda, California, Doolittle served in the Mediterranean Theater for the remainder of World War II. (HomeOfHeroes.com.)

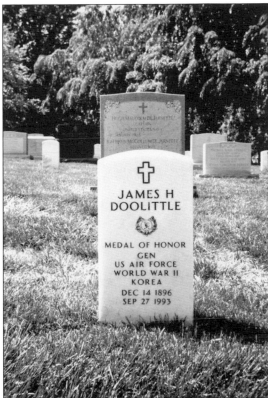

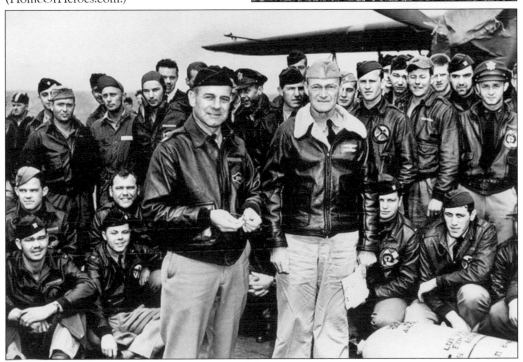

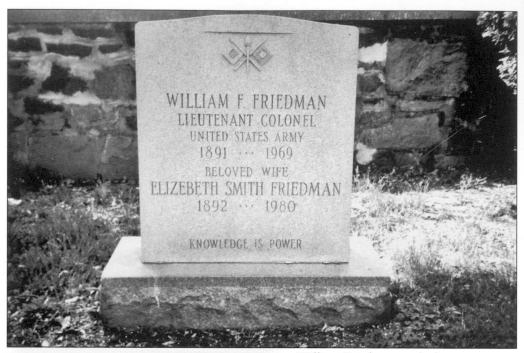

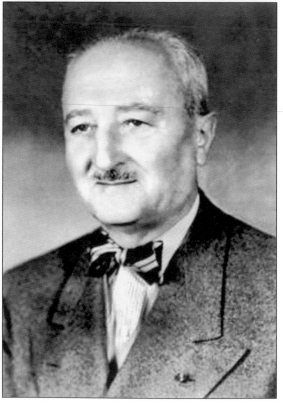

William Friedman worked as a cryptologist training officer for the army in World War I. Prior to becoming chief cryptanalyst of the War Department from 1941 to 1947, Friedman published a series of monographs on cryptanalysis—a word he coined as the study of breaking codes. During World War II, navy forces used information that Friedman's team had obtained to break the Japanese code and surprise the Japanese Navy at the Battle of Midway. A native of Kishinez, Russia, Friedman received the Medal of Merit in 1955—the highest award for civilian service. He is buried with his wife, Elizabeth, who also was a cryptologist. In 1957, she and William published *The Shakespearean Ciphers Examined*, debunking the notion that Sir Francis Bacon had written works attributed to William Shakespeare. Elizabeth and William Friedman were inductees in the 1999 class of the National Security Agency Hall of Honor. (Courtesy of National Security Agency.)

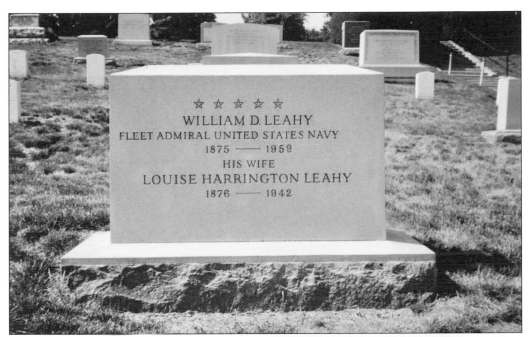

Adm. William Leahy retired in 1939. However, the Second World War led to his recall in 1942, and he became the first chief of staff to Presidents Franklin D. Roosevelt and Harry S. Truman, although, in 1949, Gen. Omar Bradley would later receive the title of and be the first formal chairman of the joint chiefs of staff. In 1944, Leahy was promoted to five-star fleet admiral. An Iowa native, Leahy also served in the Spanish-American War. In World War I, Leahy transported troops and supplies to France, eluding the German Navy. An 1897 graduate of the Naval Academy, he opposed the atomic bombings of Japan as unethical as the targets included women and children. Herbert Schonland of Portland, Maine, helped save the USS *San Francisco* off Savo Island in November 1942, after it was damaged in an enemy attack that killed or wounded all the superior officers on board. Admiral Schonland, a 1925 Naval Academy graduate, taught for much of his career.

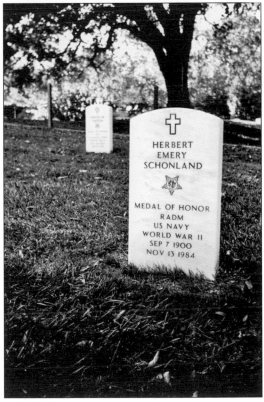

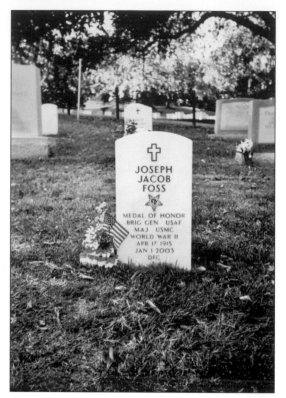

Joseph Foss was a top gun of the Marine Corps in World War II. In his 4F4 plane, he downed 23 Japanese aircraft in 41 days of nearly daily combat beginning October 9, 1942, at Guadalcanal. On January 15, 1943, he shot down three more planes using his tactic of flying close to an enemy plane to engage in short-range firing. Foss received his Medal of Honor from Pres. Franklin D. Roosevelt on May 18, 1943, with his mother and spouse present. He served as governor of South Dakota from 1955 to 1959, commissioner of the American Football League from 1959 to 1966, and president of the National Rifle Association from 1988 to 1990. For 10 years, Foss hosted an outdoorsman television series and participated in many charities. He is the subject of several books, including *A Proud American*, authored by his wife, Donna Wild Foss. (HomeOfHeroes.com.)

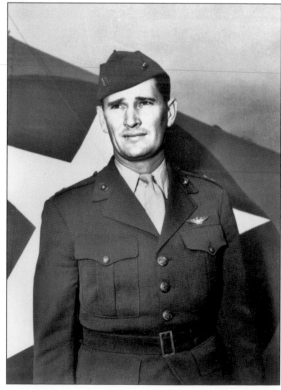

Gregory Boyington (below), a native of Coeur D'Alene, Idaho, received the Medal of Honor for aerial achievements with Marine Fighting Squadron 214. During attacks from September 12, 1943, to January 3, 1944, his F4U Corsair planes damaged shipping and shore installations and shot down numerous Japanese planes. Boyington was a graduate of the University of Washington, and the 1976–1978 television series *Black Sheep Squadron* is loosely based on his autobiography. The brown, polished, private granite marker of Joe Louis (Barrow), in the background behind Boyington's gravestone, includes a bas-relief of him in boxing attire as heavyweight champion. Louis is famous for his 1938 knockout victory over Max Schmeling, who graciously paid for Louis's funeral costs in 1981. Interred next to Louis is marine and actor Lee Marvin, who is well known for his portrayal of a World War II officer in the 1967 movie *The Dirty Dozen*, although he won an Oscar for *Cat Ballou*. (HomeOfHeroes.com.)

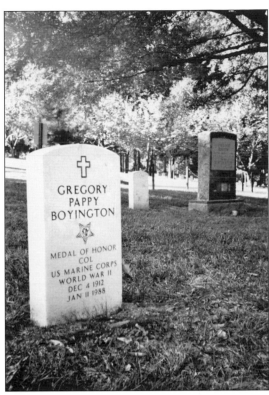

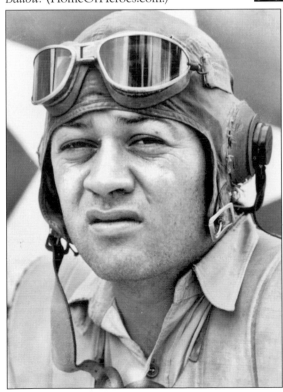

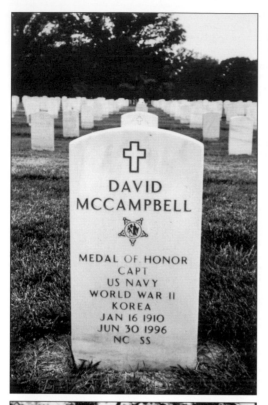

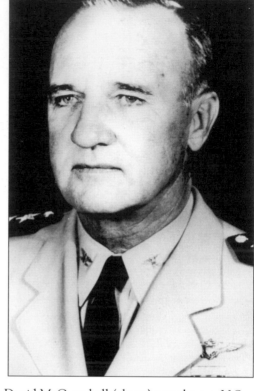

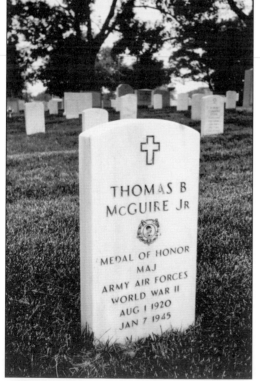

David McCampbell (above) was the top U.S. Navy fighter pilot ace during World War II with 34 "kills." Born in Bessemer, Alabama, McCampbell led a small group of fighter planes against 80 Japanese planes heading toward a U.S. fleet. He shot down seven enemy aircraft during this June 19, 1944, engagement. Then on October 24, 1944, he and one other plane attacked 60 enemy planes. McCampbell, flying a F6F Hellcat, destroyed nine Japanese aircraft, forcing them to break off their attack. He received the Medal of Honor, Navy Cross, and Silver Star.

Thomas B. McGuire Jr. was the second-highest-scoring ace of World War II with 38 kills. A native of Ridgewood, New Jersey, McGuire enlisted in the Army Air Corps— the Air Force was not a separate branch until 1947. McGuire was wounded three times in aerial combat. In his P-38, he destroyed numerous Japanese Zeros until he crashed during combat and died in January 1945. (HomeOfHeroes.com.)

Anthony McAuliffe, seen below addressing his troops, was a native of Washington, D.C., and a West Point graduate. On D-Day, June 6, 1944, he parachuted with his 101st Airborne Division into Normandy. The German Army began a winter offensive on December 16, 1944, aimed at splitting the Allied force by breaking through to the Meuse River. The element of surprise was with the attackers. However, U.S. forces resisted the German offensive, which took place in snow and freezing temperatures. The commanding officer of the surrounded U.S. forces at the strategic road junction town of Bastogne was General McAuliffe. When asked to surrender, McAuliffe formally responded, "To the German Commander: Nuts!" He received the Distinguished Service Medal for defending Bastogne, in what was known as the Battle of the Bulge, until reinforcements arrived. (HomeOfHeroes.com.)

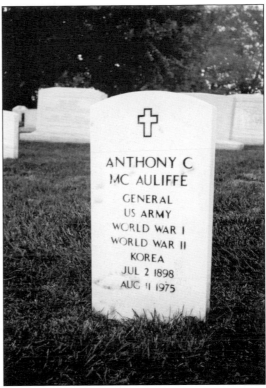

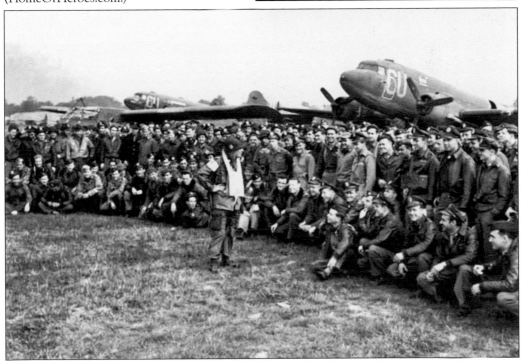

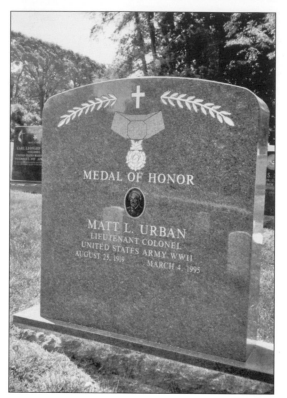

On June 14, 1944, at Renouf, France, Capt. Matt Urban (pictured below) destroyed two German tanks with a bazooka and was wounded—the first of seven wounds he would receive in a series of battles in which he distinguished himself with "bold, heroic actions." On July 25, 1944, at St. Lo, France, the native of Buffalo, New York, mounted a tank, and while exposed to heavy fire, he operated the tank's machine gun until the German position was taken. Urban was fighting against a Nazi regime that, during the Holocaust, systematically exterminated millions of targeted minority groups—primarily European Jews. His 29 medals are exceeded in number only by those of Audie Murphy—the most decorated U.S. soldier in World War II. (HomeOfHeroes.com.)

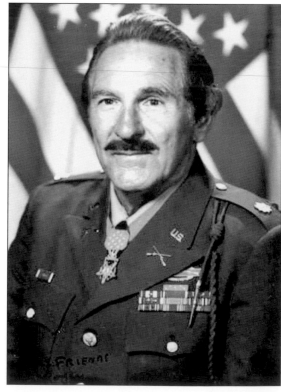

Audie Murphy was the son of a sharecropper from Hunt County, Texas. He was among the 4,500 casualties his division sustained in the southern France Allied invasion in 1944. During a German Panzer tank attack on January 26, 1945, near Holtzwihr, France, Murphy ordered his men back and by telephone gave coordinates to direct a U.S. artillery strike. He then mounted a burning U.S. tank and, while exposed to enemy fire from three sides and with a single machine gun, thwarted a German infantry advance. For his extraordinary heroism, during which the enemy sustained about 50 men killed or wounded, Murphy was awarded the Medal of Honor—one of his 33 medals. He pursued an acting career, appearing in more than 40 movies, such as Civil War classic *The Red Badge of Courage* (1951) and his biographical film *To Hell and Back* (1955). (HomeOfHeroes.com.)

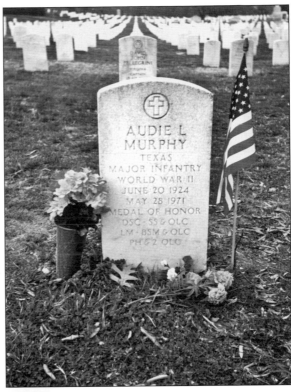

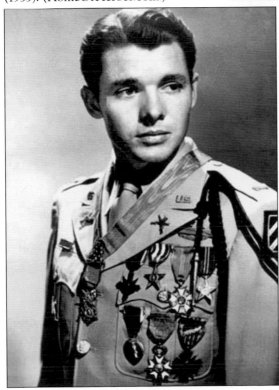

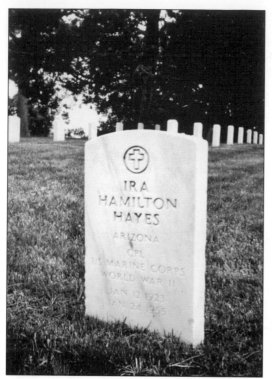

On February 23, 1945, on Mount Suribachi on the island of Iwo Jima, photographer Joe Rosenthal captured the second U.S. flag raising—the first flag was deemed to be too small. The photograph, taken on the fifth day of fighting, inspired the sculpture of the U.S. Marine Corps War Memorial located just outside the gates of Arlington National Cemetery. Inside the cemetery gates are three of the six flag raisers. Ira Hayes, whose hands have released the flagpole, was a Pima Indian from Sacaton, Arizona. When Pres. Franklin D. Roosevelt saw the photograph, he wanted the flag raisers to lead the seventh War Loan Tour—the highest grossing of the eight bond drives of the war. Hayes wanted to stay with his unit but was ordered stateside and later said, "It's funny what a picture can do." The men were seen as heroes as the Bond Tour took them through cheering crowds in major cities across the United States. (National Archives.)

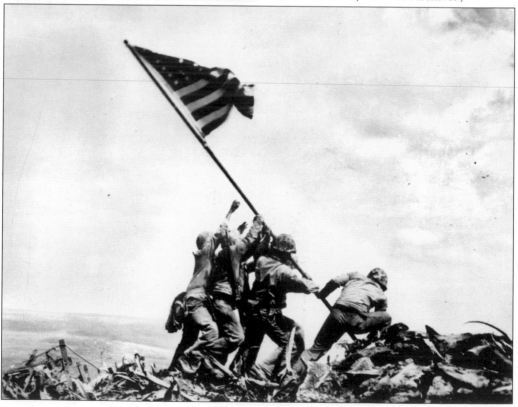

The opposite side of Rene Gagnon's headstone has a bronze replica of the Iwo Jima flag raising. Gagnon carried the flag up Mount Suribachi. Located on one end of the island, Suribachi had deceptively little resistance as the network of Japanese caves and tunnels was concentrated on a line through the width of the island. Ninety-five percent of the 22,000 Japanese on the island—whose strategic importance was the airfield—were killed while tenaciously defending it. U.S. casualties for the five-week battle totaled 28,686, of which 5,931 were killed. Among the dead were flag raisers Michael Strank, Harlon Block, and Franklin Sousley, with only Strank being buried in Arlington. The surviving flag raisers, Hayes, Gagnon, and navy pharmacist mate John H. Bradley, would portray themselves in the *Sands of Iwo Jima* (1949) with actor John Wayne and were present for the 1954 dedication of the Marine Corps Memorial in Arlington.

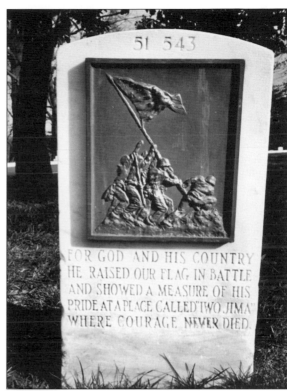

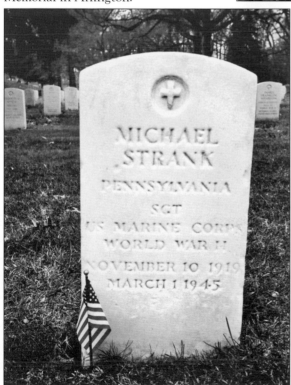

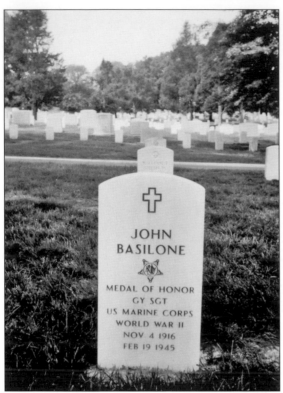

John Basilone, known as "Manila John," was a boxer with a record of 19-0 while in the U.S. Army. He enlisted in the Marines in July 1940, leaving his parents, Salvatore and Dora, and nine siblings in Raritan, New Jersey. On October 24–25, 1942, at the Battle of Guadalcanal—with only 15 men, 12 of whom were killed—Sergeant Basilone, with a heavy machine gun, fought off nearly 3,000 Japanese solders while protecting Henderson Airfield. For his actions, Basilone became the first Marine to receive the Medal of Honor in World War II. Gen. Douglas MacArthur referred to him as a "one man army." Ordered stateside to promote war bonds, Basilone was offered an officer's commission but refused stating he was a "plain soldier" and not a "museum piece." At his insistence, he returned to combat duty. He was killed on February 19, 1945, at Iwo Jima after capturing an enemy blockhouse. (HomeOfHeroes.com.)

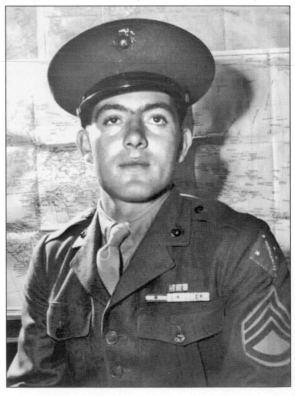

Willie Glenn Beckner, age 20, from Roanoke, Virginia, was a M4A3 (Sherman) tank gunner. Despite being only five-foot-three, he was the company peacemaker. Beckner was also a piano player and performed "Somebody Stole My Gal" the night before the 8th U.S. Armored Division was to cross the Rhine River into Germany. At dawn on March 28, 1945, as his tank entered the town of Kirschhellen, an anti-tank missile burst into the tank, opposite the "Avenelle" inscription and exterior picture of a girl that had been painted by him. The projectile killed Beckner—who was listed as missing in action. After the war, private Dick Kemp visited Leora and Henry Beckner—a barber in the Blue Ridge Mountains—to advise them of the fate of their only child. In 1989, Leora Beckner (above) came to grieve at Arlington and posed at her son's memorial. (Courtesy of Dick Kemp.)

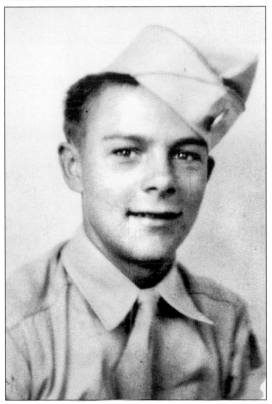

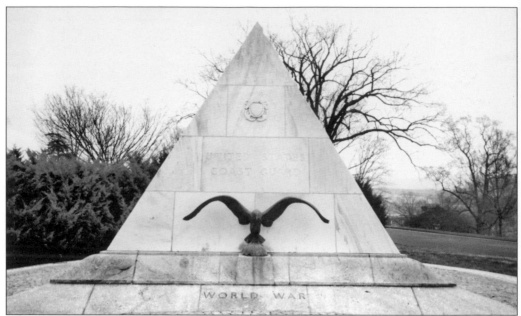

The Coast Guard memorial was dedicated May 23, 1928 and honors the officers and crew of two vessels sunk during World War I. The memorial includes a bronze seagull poised at the base of a pyramid atop a rock formation. Through its history, the Coast Guard has been involved with transports and amphibious landings (Guam and Normandy in World War II), environmental protection (America's fisheries), search and rescue (Viet Nam), and is now part of the Department of Homeland Security. Russell Waesche, a Coast Guard Academy graduate and native of Thurmont, Maryland, spent 19 of his first 20 years of service at sea. In World War I, he commanded a navy transport. Waesche was promoted to Coast Guard commandant in 1936. During World War II, he was in charge of 160,000 men and women. In 1944, Waesche became the first Coast Guard officer to attain four-star admiral status.

Benjamin O. Davis, a native of Washington, D.C., enlisted in the U.S. Army in 1898. He was a professor of military tactics at Tuskegee, Alabama. In October 1940, he became the first African American general in the U.S. Army. General Davis served in Europe during World War II as did about 500,000 African Americans. Davis is pictured in France with the Signal Corps. African American soldiers were not allowed into combat units until 1944. Pres. Harry S. Truman, in his authority as commander in chief, initiated desegregation in the armed forces when he signed an executive order in 1948 that "there shall be equality of treatment and opportunity for all persons in the armed services without regard to race, color, religion or national origin." General Davis was awarded the Distinguished Service Medal "for exceptionally meritorious service." (National Archives.)

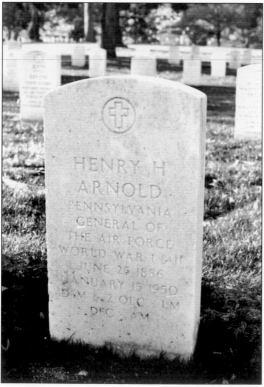

The successful working alliance between England and the United States during World War II is epitomized in Sir John Dill—a British field marshal assigned as the representative of the British chief of staff in Washington, D.C. Born in Northern Ireland, Dill worked closely with Gen. George C. Marshall, who described him as having "remarkable courage in carrying out his duties" and that "Dill won the antagonism of [Prime Minister Winston] Churchill by being absolutely frank." Dill died in 1944, and his equestrian monument was unveiled in 1950 (above). Gen. Henry (Hap) Arnold, from Gladwyne, Pennsylvania, was a pioneer aviator who learned to fly in 1911 in a Wright Flyer purchased by the U.S. Army. As chief of the Air Corps, he encouraged the technological development of fighter planes and long-range bombers that helped provide air superiority during World War II. To date, he is the only Air Force five-star general. (George C. Marshall Foundation.)

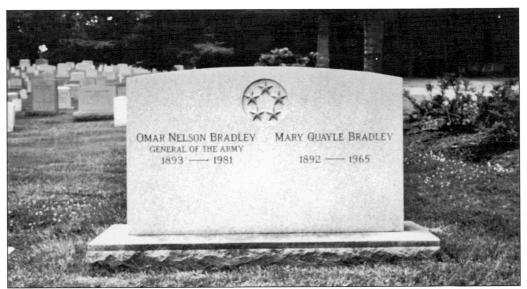

Five-star general Omar N. Bradley was born in Clark, Missouri. He graduated from West Point in 1915 with classmate Dwight D. Eisenhower. In his autobiography, *A Soldier's Story*, Bradley discussed the Allied problems in planning the Normandy attack to breach the German Atlantic Wall: the maintenance of air superiority, how many divisions could be put ashore on landing craft, the number of reserve enemy divisions that could respond to the invasion, ensuring a flow of supplies and maintaining the element of surprise. He discussed Eisenhower's command decision to proceed on June 6, 1944, despite the initial bad weather—which fortunately "spared us enemy detection." Having successfully landed on the Normandy beach, a helmeted Bradley greets Gen. George C. Marshall (center) and Gen. Hap Arnold. Bradley's initiative in taking the Remagen Bridge on March 7, 1945, led to the Rhine River crossing that hastened the end of war in Europe. (George C. Marshall Foundation.)

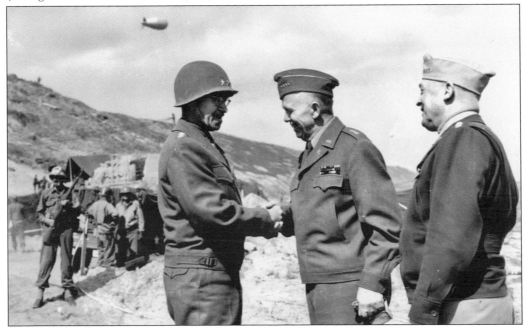

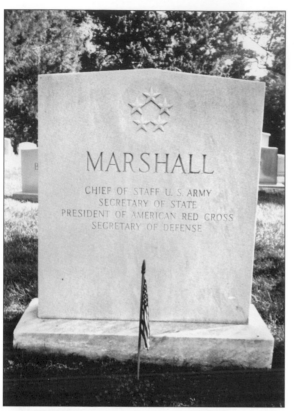

Gen. George C. Marshall, of Uniontown, Pennsylvania, was the main U.S. military strategist of World War II. A 1901 graduate of the Virginia Military Institute, Marshall was on Gen. John Pershing's staff in World War I. He was appointed as U.S. Army chief of staff on September 1, 1939. In trying to effectuate a unity of command against the Germans, he confronted Winston Churchill, who, at first, opposed an infantry general controlling the British Navy. Marshall considered George Patton a "clever leader" and a skillful, talented commander. However, when Patton sought the promotion of a staff member, Marshall replied, "This is not the time to bring this up. This is a social gathering, not a business meeting. I am speaking now as the chief of staff to General Patton and not to my friend General Patton." His economic recovery proposal of postwar Europe is known as the "Marshall Plan." Pictured below is the 1959 funeral service of five-star general Marshall. (George C. Marshall Foundation.)

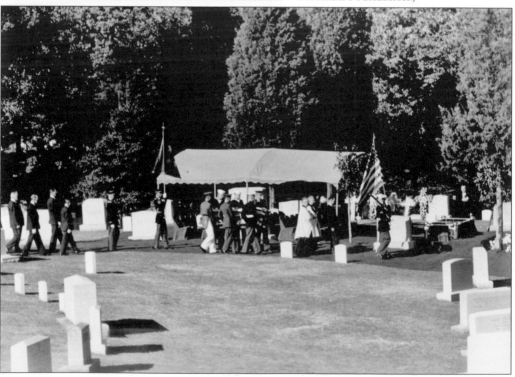

Marge V. Lederer, a native of Irvington, Essex County, New Jersey, and the youngest of four siblings, joined the U.S. Army (Women's Army Corps, or WAC) in 1943. She was one of 150,000 women who served in the WAC during World War II. Although Gen. George C. Marshall was in full support of the WAC, there was still resistance by the public and some military officials to accepting women in the military. The magnitude of the largest armed conflict in world history, however, required additional active support, which women provided both in the military and on the U.S. home front. Lederer's overseas assignments included Germany and Japan. Her duties as a physician's assistant and nurse practitioner included work in surgical wards, post- and pre-operative care, and the management of medical supplies. Sergeant Lederer was on active duty for 22-and-a-half years and in the reserve worked with the Defense Intelligence Agency in Arlington—where she resided.

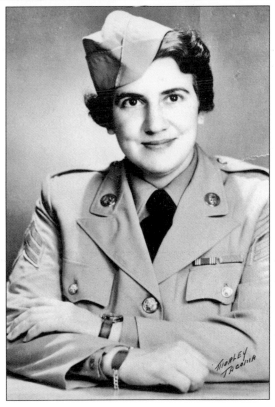

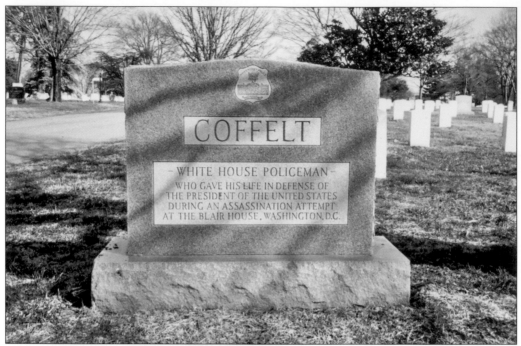

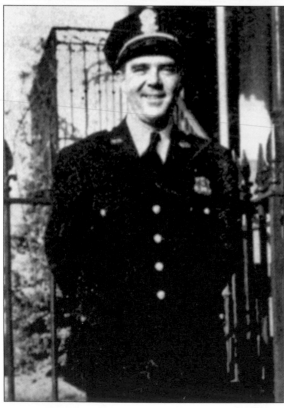

On November 1, 1950, Leslie Coffelt, an expert shooter, was on guard duty at the Blair House—the residence of Pres. Harry S. Truman during the renovation of the White House. Two Puerto Rican nationalists, Griselio Torresola and Oscar Collazo, approached the Blair House at 2:20 p.m. intending to assassinate Truman. They began firing pistols, striking policemen Joseph Downs and Donald Birdzell, each of whom survived, and Coffelt. Despite three fatal bullet wounds, Coffelt staggered out of his guard booth and fired one shot at Torresola's head—killing him. President Truman was on the second floor and upon hearing the gunshots approached a window. He was preparing to depart for Arlington National Cemetery for the 3:00 p.m. dedication of the equestrian monument of British field marshal Sir John Dill. Harry Truman, a Past Grandmaster of Masons in Missouri, attended the Arlington interment of Leslie Coffelt— a fellow Mason and Virginia native.

The Korean War was a "cold war" confrontation with communist ideology that resulted in a limited, but nonetheless brutal, war of narrow political objectives—to liberate and protect South Korea. On June 25, 1950, North Korean forces invaded Korea's southern peninsula, capturing Seoul. By July 1, 1950, U.S. troops were in South Korea, and from September to November, the enemy was pushed north of the 38th parallel. U.S. forces then encountered Chinese soldiers at the Changjin Reservoir. Capt. Carl Sitter, a native of Syracuse, Missouri, led Company G of the 1st Marines up a steep, snow-covered hillside and seized a strategic enemy position. In 36 hours of fighting and repulsing a night counterattack, Sitter was seriously wounded by grenades but refused to abandon his men. He encouraged and redeployed troops until the area was secure. The Masonic compass and square and the Rotary International seal are on the obverse side of Sitter's marker. (HomeOfHeroes.com.)

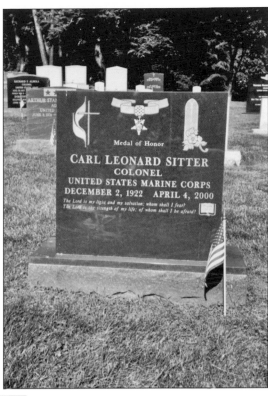

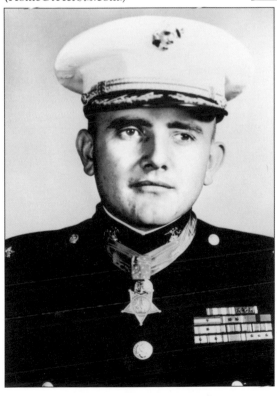

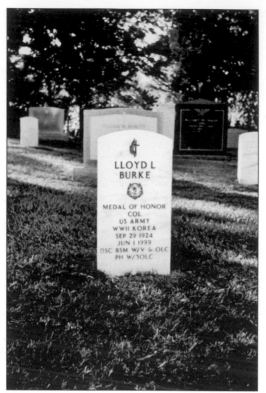

Lloyd Burke, born in Tichnor, Arkansas, received the Medal of Honor from President Truman for conspicuous gallantry on October 28, 1951, in Chong-dong, Korea. During the battle, Burke, acting alone, assaulted three enemy bunkers. He attacked the first bunker with grenades and his M-1 rifle—killing the entire crew. He charged the center emplacement and threw grenades through an opening and then with his pistol killed three more enemy soldiers. Burke's Medal of Honor citation states that he approached the third bunker "catching several grenades in midair and hurling them back at the enemy." Burke then secured a light machinegun, set up the gun, and fired into the enemy position, killing about 75. He was then wounded but maintained his attack, destroying two mortar sites and a machine gun position. He again moved forward and killed around 25 of the enemy. Burke was also wounded in the Vietnam War. His marker lists multiple medals and his Methodist affiliation. (HomeOfHeroes.com.)

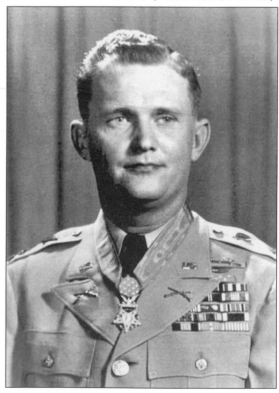

James Johnson of Pocatello, Idaho, was killed in combat at Yudam-ni, Korea on December 2, 1950. A World War II veteran, he directed his platoon's rifle fire and when a displacement was ordered, Sergeant Johnson placed himself in an exposed position to provide covering fire for his men. He was last seen "in a wounded condition single-handedly engaging enemy troops in close hand grenade and hand-to-hand fighting." Johnson's action permitted his platoon to withdraw and saved many lives. The citation of Johnson concludes that "his dauntless fighting spirit and unfaltering devotion to duty in the face of terrific odds reflect the highest credit upon himself and the U.S. Naval Service." On a steep hillside in Arlington Cemetery a "memory" headstone cites the date he was presumed dead, as his remains were never located in Korea. Also pictured is a Canadian Cross wreath-laying ceremony conducted in the 1930s. Canada supported Allied war efforts from World War I through Korea. (National Archives.)

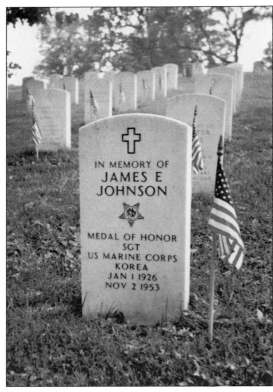

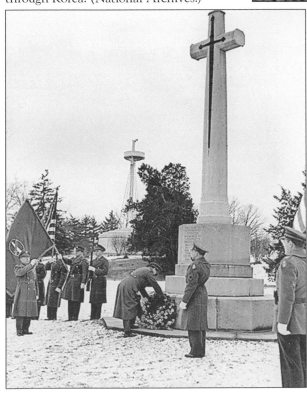

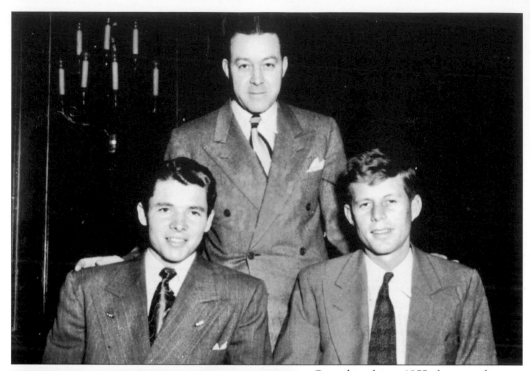

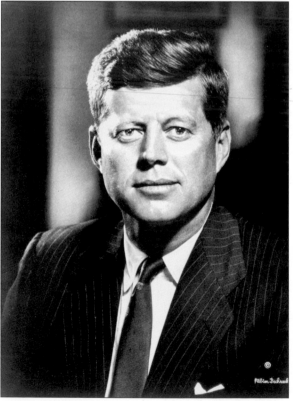

Seated in this *c.* 1955 photograph is Medal of Honor recipient Audie Murphy (left) with Sen. John F. Kennedy. In May 1963, Pres. John F. Kennedy hosted a White House lawn party for 240 Medal of Honor awardees. The oldest recipient to attend was Charles Kilbourne Jr., who received his Medal of Honor for heroics in the 1899 Philippine Insurrection. He died in 1963 and is buried in Arlington. If the status of Arlington National Cemetery as the preeminent U.S. military cemetery were not secured with the burial of hundreds of Medal of Honor recipients, then its stature was virtually guaranteed with the interment of John F. Kennedy. A native of Brookline, Massachusetts, Kennedy graduated from Harvard in 1940. As a navy lieutenant of the PT-109, his patrol boat was struck by a Japanese destroyer on August 2, 1943, near the Solomon Islands. An injured Kennedy rescued three crewmen—towing one wounded sailor three miles in the ocean to safety. (Robin Moss.)

Jacqueline Kennedy Onassis, born in Southampton, New York, attended Vassar and graduated from George Washington University in D.C. A photographer, she and Kennedy married in 1953. Her beauty, intelligence, and interest in the arts elevated her to iconic status and altered the function of a first lady. She defined her role as taking care of the president but also said, "If you bungle raising your children, I don't think whatever else you do well matters very much." President Kennedy's vision is evident in his 1961 creation of the Peace Corps and his space program initiative: "We choose to go to the moon in this decade and do things, not because they are easy, but because they are hard." Media coverage of nearly every aspect of the November 25, 1963, Kennedy funeral procession and service—with the interment site just below Arlington House—further cemented in the public's mind that the ideals of democracy rested on Arlington's hillsides. (Harry S. Truman Library.)

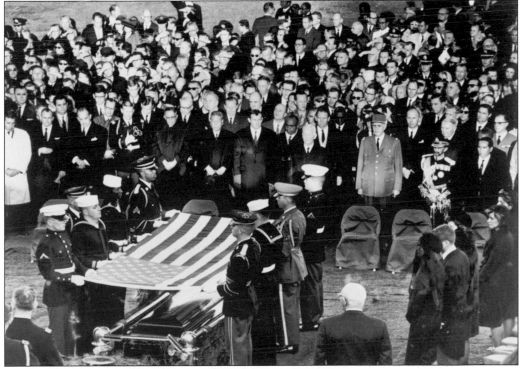

Pres. John F. Kennedy's televised presentation to the nation on June 11, 1963, was another layer in the protracted civil rights movement as he pleaded for racial harmony. After the broadcast, Byron de la Beckwith, a white racist, went to the residence of Mississippi NAACP leader Medgar Evers after midnight and shot him in the back with a high-powered rifle. Evers had served his country in World War II and, after graduating from Alcorn State, was trying to bring about change. Attorney Gen. Robert F. Kennedy, a Harvard graduate with a law degree from the University of Virginia, was integral in the passage of the Civil Rights Act of 1964. While a U.S. senator from New York, Robert Kennedy was assassinated after his 1968 presidential primary victory in California. Sen. Edward Kennedy's eulogy of his brother concluded "Some men see things as they are and say why. [Robert dreamed] things that never were and [said] why not."

Gen. Creighton W. Abrams Jr., a native of Springfield, Massachusetts, was awarded the Distinguished Service Cross for his actions on September 9, 1944, and December 26, 1944—where he spearheaded the breakthrough of the German encirclement at Bastogne and reportedly said "they've got us surrounded again, the poor bastards." Gen. George S. Patton praised Abrams by saying, "I'm supposed to be the best tank commander in the Army, but I have one peer: Abrams." Seen below with Robert F. Kennedy, he replaced Gen. William Westmoreland to lead the U.S. forces in Vietnam and, amidst an extremely unpopular war, significantly decreased troop strength from 1968 to 1971. Julia Abrams, his wife and a graduate of Vassar, founded the Army Arlington Ladies—a corps of volunteer women—one of whom attends every burial service at Arlington. (*Stars and Stripes.*)

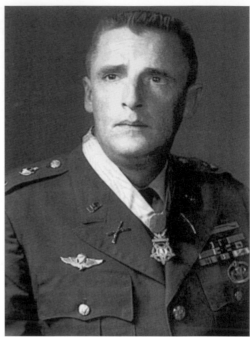

At Con Xoai, Viet Nam, the extraordinary heroism of Charles O. Williams (above) of the 5th Special Forces Group on June 9–10, 1965, saved his outfit during a 14-hour Vietcong attack. Despite three wounds, he used a rocket launcher to destroy an enemy machine gun over 160 yards away. The unflappable South Carolinian was then struck a fourth time. In the 1965 Battle at Ia Drang, 450 U.S. soldiers were surrounded by 2,000 North Vietnamese regulars. According to his commanding lieutenant, Calvin Bouknight performed "stunningly heroic acts" as a medic during the shooting by "treating four or five" wounded men by placing his body between them and enemy fire until he was mortally wounded. Bouknight, an African American, was a native of Washington, D.C. (HomeOfHeroes.com.)

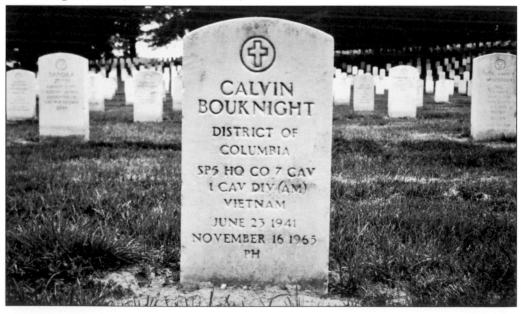

William Richard Spates Jr. was a Tomb of the Unknowns sentinel commander at Arlington National Cemetery from 1964 to 1965. A native of Kensington, Maryland, he oversaw the sentinel guards' hourly 21-step walk—the 21 steps reflecting the highest form of salute. The hourly changing of the guard is among the cemetery's most popular attractions. The Honor Guard of the 3rd U.S. Infantry serves as a 24-hour-a-day guardian of the Tomb of the Unknowns. Spates was killed in 1965 at Pleiku, Vietnam. His family included his wife, Felicia; daughter, Tracy;, brothers, James, Michael, and Gerald; and sisters, Margaret and Mary Catherine. Spates Community Center at Fort Myer, Arlington is named in his honor. He is the first tomb sentinel to be killed in battle. Also pictured is this c. 1930s postcard of a tomb sentinel on duty in Arlington.

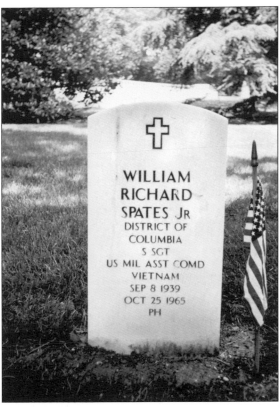

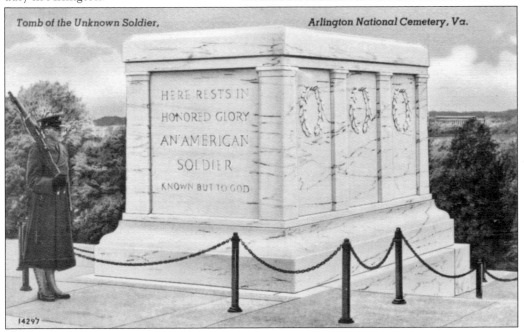

Tomb of the Unknown Soldier, Arlington National Cemetery, Va.

HERE RESTS IN HONORED GLORY AN AMERICAN SOLDIER KNOWN BUT TO GOD

14297

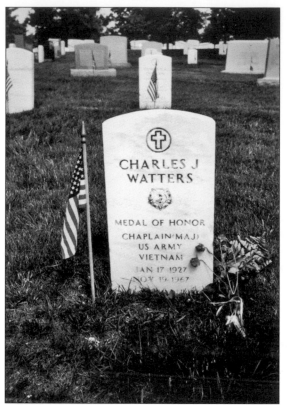

Buried on Chaplain's Hill in Arlington Cemetery is U.S. Army chaplain Charles Watters. A native of Jersey City, New Jersey, he conducted numerous services during his 15-month tenure in South Vietnam, including some in coastal waters, as pictured below. On November 19, 1967, during a battle near Dak To in the Kontum province, Watters ran in front of the assaulting forces of the enemy and assisted at least seven wounded soldiers—some of which he carried to safety. He was unarmed and exposed to intense automatic weapon fire as he conducted himself beyond the call of duty. When all the wounded had been placed inside the defensive perimeter, he applied field bandages to wounds, provided food and water, and administered spiritual comfort until he was mortally wounded. In 1969, Watters's two brothers accepted his posthumous Medal of Honor. He is one of seven Catholic chaplains who died in Vietnam. (HomeOfHeroes.com.)

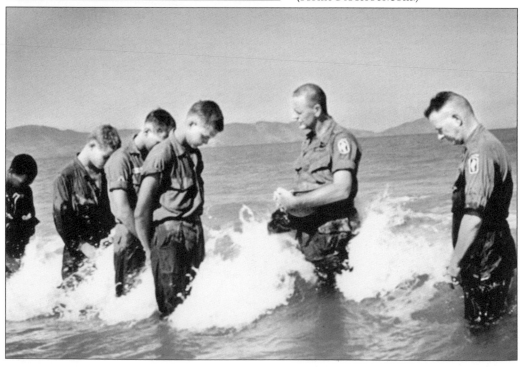

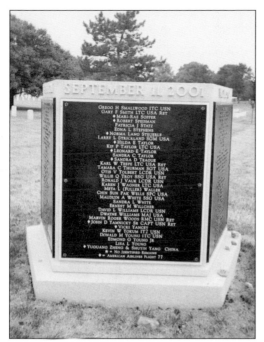

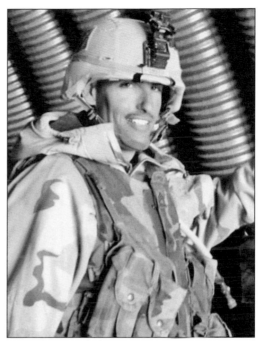

On September 11, 2003, the Pentagon Group Burial Marker was dedicated at Arlington National Cemetery. It is located in Section 64, not far from the west wall of the Pentagon—site of the September 11, 2001, terrorist attack. Of the 184 persons who died when the hijacked American Airline Flight 77 crashed into the Pentagon, 64 are interred in Arlington at various locations. On April 4, 2003, near Baghdad International Airport in Iraq, about 100 U.S. engineers were attacked by a larger enemy force. According to the posthumous Medal of Honor citation of Sgt. Paul R. Smith, he "moved under withering enemy fire to man a .50 caliber machine gun mounted on a damaged armored personnel carrier." His heroism permitted the withdrawal of numerous wounded soldiers and thwarted the attack—killing about 50 enemy soldiers. Surviving Smith, a Persian Gulf War veteran who grew up in Tampa, Florida, are his wife and two children. (HomeOfHeroes.com.)

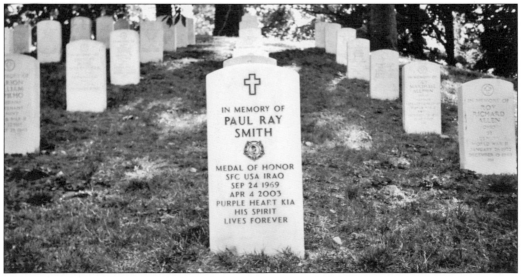

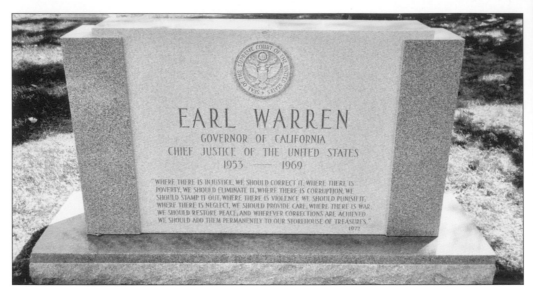

Earl Warren was chief justice of the U.S. Supreme Court from 1953 to 1969. Landmark decisions of his court include the equal protection violations found in disproportionate voting strength from one district to another in the "one man, one vote" rule in *Baker v. Carr* and *Reynolds v. Sims*. The due process clause of the 14th Amendment was interpreted in the right to counsel case of *Gideon v. Wainwright* and the right to remain silent during the custodial interrogation case of *Miranda v. Arizona*. First Amendment protection of the press was extended in *New York Times v. Sullivan* as malice became the standard in libel cases regarding a public official. The unanimous decision written by Warren in *Brown v. Board of Education* overturned the "separate but equal" doctrine and invalidated racial segregation in public schools. The former California governor also chaired the commission that concluded that John F. Kennedy was killed by Lee Oswald, acting alone. Pictured below center are, from left to right, President Kennedy, Jacqueline Kennedy, Chief Justice Earl Warren, and Nina Warren at a 1963 judicial reception. (John F. Kennedy Library.)

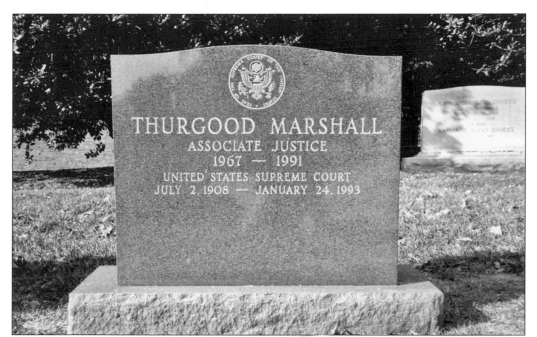

Thurgood Marshall, born in Baltimore, Maryland, graduated from Lincoln University. In 1933, he finished first in his law school class at Howard University. As counsel for the National Association for the Advancement of Colored People from 1936 to 1961, Marshall prevailed in 29 of 32 cases that he argued before the Supreme Court. He championed civil rights cases regarding employment, housing, public accommodation, transportation, and education, such as the *Brown v. Board of Education* case. Marshall was nominated to the U.S. Court of Appeals by Pres. John F. Kennedy. None of his 98 majority opinions were reversed. He then served as solicitor general for the federal government and won 14 of 19 cases before the Supreme Court. In 1967, Marshall became the first African American to serve on the U.S. Supreme Court. Despite his success, upon his retirement in 1991, Marshall defined his legacy as "That he did what he could with what he had."

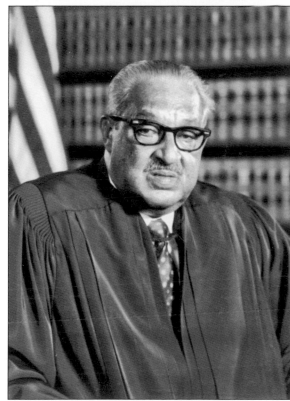

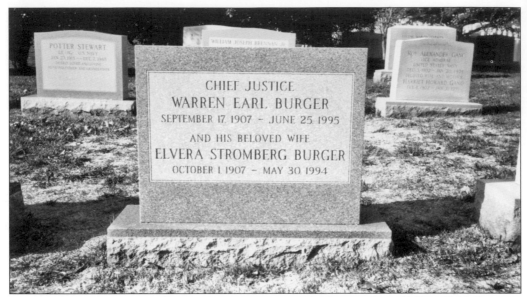

Warren E. Burger, a native of St. Paul, Minnesota, was chief justice from 1969 to 1986. Burger is pictured below swearing in Henry A. Kissinger as secretary of state in September 1973 as Pres. Richard M. Nixon and Paula Stern Kissinger, Henry's mother, look on. During his tenure, the court found reverse discrimination in school admission quotas in the *Regents of the University of California v. Bakke* case. The most discussed ruling of the Burger era was the right to privacy case, which prohibited a ban on all abortions—*Roe v. Wade*. In 1974, he founded the Supreme Court Historical Society. Chief Justice Burger was a strong advocate for a more efficient judicial system. The chief justice's initiatives include the American Inns of Court, the Institute for Court Management, the National Institute of Corrections, the National Institute for State Courts, and the State of the Judiciary speech to the American Bar Association. In 1986, he chaired the U.S. Constitution Bicentennial Commission.

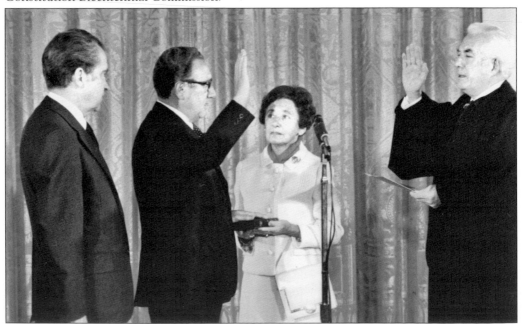

Chief Justice William H. Rehnquist served in the U.S. Army Air Corps during World War II. A native of Milwaukee, Wisconsin, he became an associate justice of the Supreme Court in 1972 and chief justice in 1986. Rehnquist's opinion in *National League of Cities v. Usery* (1976) began the process of reviving the 10th Amendment, which reads, "The powers not delegated to the United States by the Constitution nor prohibited by it to the States, are reserved to the States respectively, or to the people." Congressional authority had grown significantly and had been permitted to do so by previous courts' interpretation of the commerce clause of the Constitution, a document designed to contain governmental power. Rehnquist opined that the 10th Amendment imposed substantive limitations on congressional legislation. His opinions helped define the relationship between federal and state governments—carving out certain authority to the states. (Library of Congress.)

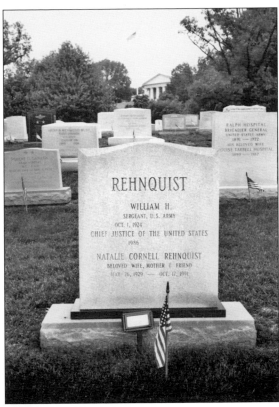

Engineer George Westinghouse was credited with more than 360 patents. Born in Schoharie County, New York, he learned about mechanics at his father's farm machinery factory. His railroad inventions included an air brake that could be operated by the engineer, the "frog" track switch, and a device to mount derailed cars. Westinghouse met his wife, artist Marguerite, on a train. His interest in electrical power distribution led to a bitter "war of currents" with Thomas Edison, an advocate of a low-voltage direct current (DC) power network. Westinghouse pursued the technology of an alternating current (AC) power distribution. By providing electrical lighting at the 1893 Exposition in Chicago and in 1895 harnessing the Niagara Falls to produce electricity in Buffalo, he proved the value of an AC system and that its advantages (long-range power) outweighed its danger. He also developed car shock absorbers and a system to transmit natural gas.

HENRY MARTYN ROBERT
BRIGADIER GENERAL
CHIEF OF ENGINEERS
UNITED STATES ARMY
1837 — 1923
HIS WIFE
ISABEL HOAGLAND ROBERT
1862 — 1957

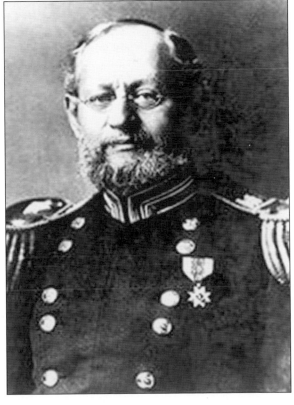

Henry Robert, a native of South Carolina, graduated from West Point and served in the Corps of Engineers, becoming chief of engineers in 1901. After presiding over a turbulent church meeting, Robert sought guidance on how to maintain control and order over groups and meetings but discovered that there was no parliamentary procedure that was generally accepted. He then prepared and in 1876 self-published his own 176-page *Pocket Manual of Rules of Order*. The revised version, better known as *Robert's Rules of Order*, established methodical principles for motions, debate, and voting at meetings. His classification of motions included main motions or new resolutions; subsidiary motions, such as the motion to table or lay aside; incidental motions, point of order; and privileged motions, for example the motion to adjourn, which cannot be amended or debated. (U.S. Army Corps of Engineers.)

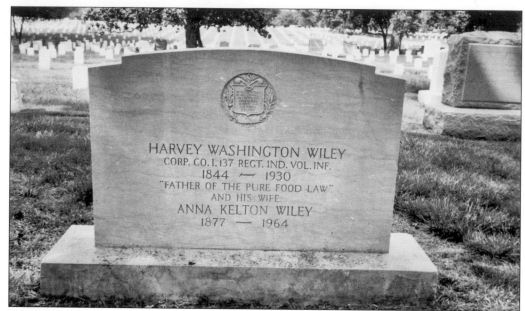

Harvey W. Wiley, a crusading chemist and author of *Foods and Their Adulteration* (1907), worked with the U.S. Department of Agriculture. He is buried alongside the Union interments seen in this *c.* 1865 photograph as he was in the Federal army during the Civil War. Born in Indiana, Wiley was educated at Hanover College and Indiana Medical College. As chief chemist, he studied the effects of food additives on volunteers who became known as the "poison squad." The disclosure of these studies became nationally known and instigated the movement toward federal food and drug regulation. In 1912, he supervised the laboratories of *Good Housekeeping* magazine. During his 18 years with the magazine, he established the *Good Housekeeping Seal of Approval* for products that passed safety standards. When Wiley was asked by Theodore Roosevelt whether or not he thought certain preservatives were injurious, he said, "Mr. President, I don't think, I know." (Library of Congress.)

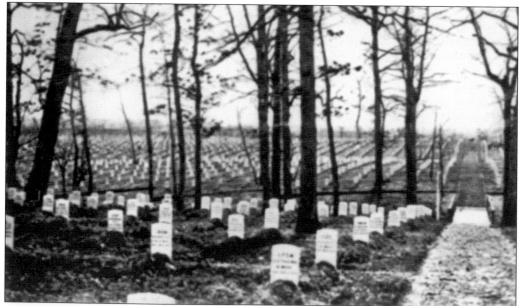

Grace Hopper was a Phi Beta Kappa graduate of Vassar College. At Yale University, she received a master's degree in mathematics and physics and a Ph.D. in mathematics. With her belief that computers should be user-friendly, Hopper participated in the development of Common Business Oriented Language or CBOL. Although she was ridiculed by those who said that computers do not understand English, Hopper persevered and pioneered the beginning of computer programming language using words rather than numbers. She alternated careers between the navy, academic teaching, and private industry. While with Sperry Rand, she worked on the first commercial computer. Hopper was among the first software engineers and also held the rank of rear admiral. When asked of her greatest contribution, she said it had been "all the young people I've trained." (Hagley Museum and Library.)

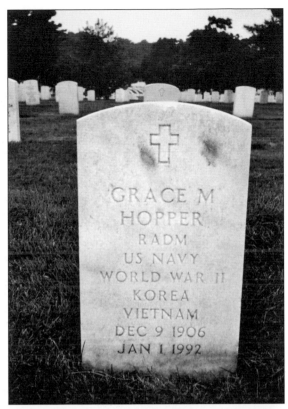

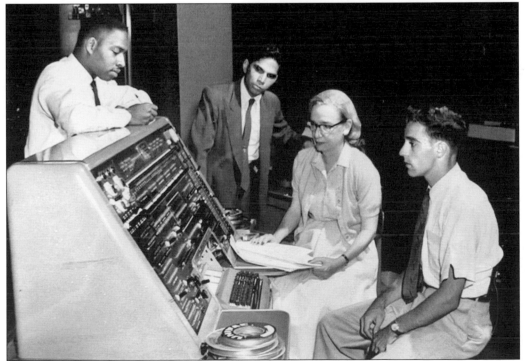

The distinguished career of Adm. Hyman G. Rickover begins with his Jewish family immigrating to Chicago, Illinois, in 1905 from the Polish city of Makow. A 1922 graduate of the U.S. Naval Academy, Rickover was assigned to the Atomic Energy Commission, where he pursued his revolutionary concept of naval nuclear propulsion. He personally examined officers under consideration for service on a nuclear ship, including future-president Jimmy Carter. His "why not the best" challenge to Carter during that interview was the source of a Carter book title. In 1982, Rickover stated: "Good ideas are not adopted automatically. They must be driven into practice with courageous impatience. . . . Nothing worthwhile can be accomplished without determination." Rickover developed the first nuclear submarine, the *Nautilus*, launched in 1954. (U.S. Naval Academy.)

Dr. Luther Terry received his M.D. from Tulane University and became surgeon general in 1961. His leadership produced the landmark *Smoking and Health* report in 1964, which linked lung cancer to cigarette smoking. Terry worked courageously for laws to eliminate cigarette advertising on radio and television, restrict sales to minors, and place health warnings on cigarette packs. He authored over 100 articles and books on public health and medical research.

Dr. Jonathan Letterman revamped the U.S. Army Medical Corps during the Civil War. A native of Pennsylvania and a graduate of Jefferson Medical College, he developed the Ambulance Corps. Letterman also implemented a three-tiered evacuation process for the battlefield: field dressing station next to the battlefield, field hospitals close by, and large hospitals distanced from the combat area. After the 1862 Battle of Antietam, his system removed thousands of wounded from the field within 24 hours.

John Wesley Powell, a native of Mount Morris, New York, was interested in geology at an early age and studied at various colleges. From 1856 to 1858, he traveled the length of the Mississippi, Ohio, and Illinois Rivers in a rowboat. During the Civil War, he was wounded in the 1862 battle at Shiloh, Tennessee, resulting in the amputation of his right arm. After teaching college geology, he conducted his first exploration of the Grand Canyon, portaging and running rapids on the Colorado River in 1869. He studied the language and customs of Ute Indians. Maps were made and photographs taken, such as the one of Powell and the wife of a Ute chief (below). Powell published *Canyons of the Colorado: The Study of Indian Languages*, served as director of the U.S. Geological Survey, was head of the Bureau of Ethnology, and helped establish the National Geographic Society. (Library of Congress.)

Robert Peary, from Cresson, Pennsylvania, graduated from Bowdoin College and joined the U.S. Navy Civil Engineering Corps. After a series of failed attempts to reach the North Pole and the loss of his toes to frostbite, Peary embarked on his last major expedition in 1908. He planned to travel wearing fur suits and building igloos as opposed to bringing tents and sleeping bags. Peary is pictured below on board the *Roosevelt* with his sled dogs prior to his making it to the polar cap on April 6, 1909. He died in 1920. Buried with him is his wife, Josephine Peary, who in 1891 became the first woman explorer of the Arctic. This Greenland trip was documented by Josephine in her 1893 book, *My Arctic Journal*. As a hunter, she used a Winchester rifle and Colt revolver. Josephine's other publications include *The Snow Baby*, about her daughter, Marie, and *Children of the North*. (National Archives.)

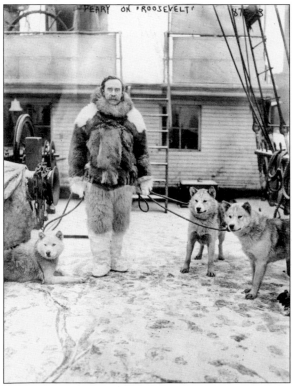

121

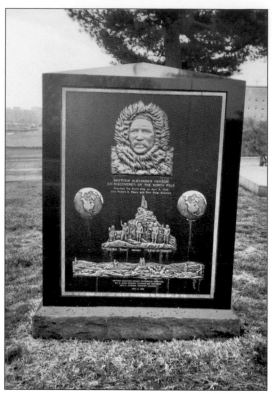

Matthew Henson, born in Charles County, Maryland, was employed as a store clerk when he met Robert Peary in 1877. Impressed with Henson's skills, Peary hired the young African American to accompany him on a surveying expedition. After a number of failed trips to reach the North Pole, Peary, Henson, and four Eskimos reached the top of the world on April 6, 1909. Henson described the adventure in his 1912 book *A Negro Explorer at the North Pole*. Peary photographed Henson centered between the accompanying Inuits at the North Pole with the American flag. Henson received little credit for his achievements. In 1911, Peary was awarded a Congressional medal and promoted to rear admiral for reaching the pole. Henson was not recognized by Congress for his efforts until 1944. (National Archives.)

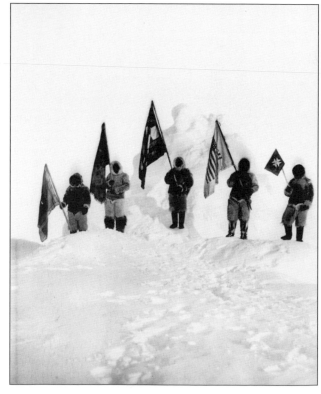

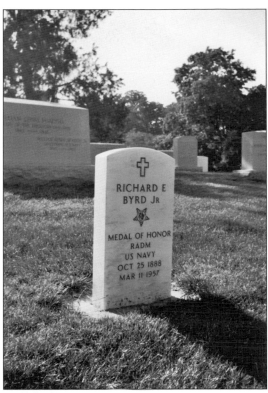

Richard Byrd, a native of Winchester, Virginia, traveled to the Philippines alone to visit his godfather at the age of 12. His desire for discovery had begun. He graduated from the Naval Academy but injured his foot and was dismissed from the service as disabled. His 1926 flight over the North Pole, for which he was awarded a Medal of Honor for his courage, and 1929 sojourn over the South Pole are firsts in polar aviation. In Byrd's bestselling 1938 book, *Alone*, based on his 1934 Antarctic winter in solitude at the Ross Ice Shelf, he stated that "it's not getting to the pole that counts. It's what you learn of scientific value on the way." Byrd, seated below, studied the region's plants and birds. (Library of Congress.)

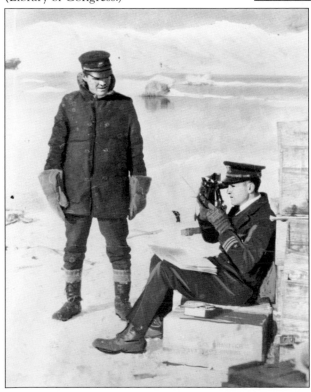

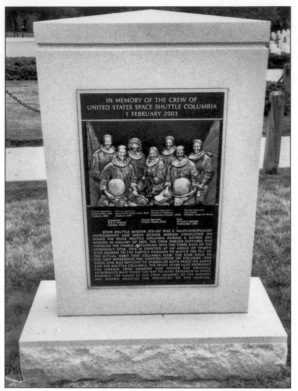

The National Aeronautics and Space Administration (NASA) Orbiter Fleet has included space shuttles *Columbia* (first flight 1981), *Challenger* (first flight 1983), *Discovery* (launched for its first flight in 1984), *Atlantis* (first flight in 1985), and *Endeavour* (first flight in 1992 as a replacement for *Challenger*). A space shuttle operates as a large orbiting laboratory and is described by NASA as "the most complex machine ever built." The scientific rewards of space exploration are tempered by disasters. A memorial (left) honors the January 28, 1986, flight of *Challenger* that exploded 73 seconds into the mission due to a boaster failure, killing the crew. The *Columbia* memorial (below) recognizes the 2003 reentry tragedy of that space shuttle.

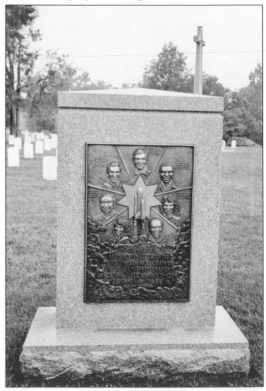

Charles "Pete" Conrad Jr., after graduating from Princeton University, entered the U.S. Navy and became a test pilot. In 1962, he was selected by NASA as an astronaut. As commander of *Apollo XII*, he was the third man to walk on the moon on November 19, 1969—just four months after astronauts Neil Armstrong and Edwin "Buzz" Aldrin's *Apollo 11* moon landing. Conrad and his crew, Richard Gordon Jr. and Alan Bean, were successful in the primary scientific objectives of the November 14–24, 1969, voyage to deploy the autonomous scientific station; retrieve for study part of the unmanned *Surveyor III*, which had landed on the moon in April 1967; and gather geological samples during his and Bean's two moon walks. He also served as commander of the first United States Space Station, Skylab I. (NASA.)

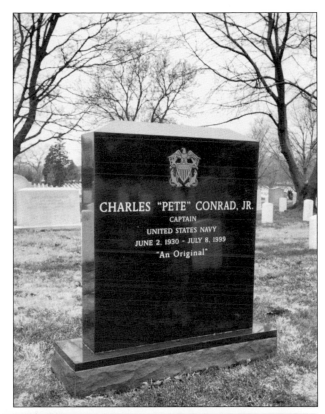

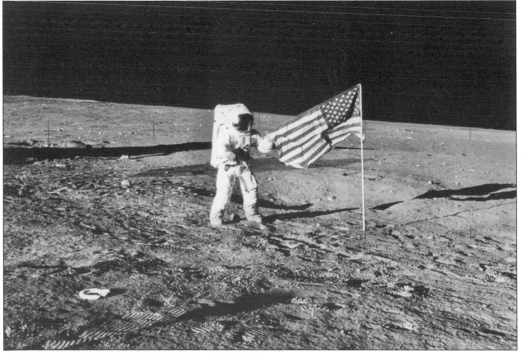

INDEX
with Burial Site Locations

Gagnon, Rene	89	Section 51, Lot 543
Green, John	57	Section 1, Lot 503, Grid KL-34/35
Harris, James H.	44	Section 27, Lot 985-H, Grid BB-48.5
Hayes, Ira	88	Section 34, Grave 479A
Henry, Guy V.	55	Section 2, Lot 991
Henson, Matthew	122	Section 8, Lot 15, Grid X-8.5
Holland, Milton M.	44, 45	Section 23, Lot 21713
Hopper, Grace	117	Section 59, Grave 973, FF 24.5
Hunter, Alexander	30, 31	Section 16, Lot 261-A
Igo, John	19	Section 13, Lot 5261
Johnson, Henry L.	70	Section 25, Lot 64
Johnson, James E.	101	Memorial Section H, Lot 451
Kautz, August V.	55	Section 2, Lot 992
Kearny, Phil	50	Special Lot S-8, Grid OP-32
Kennedy, John F.	102	Section 45, Grid U-35
Kennedy, Robert F.	104	Section 45, Grid U-33/34
La Mesa, Carlos De	15	Section 26, Lot 5227
Leahy, William	81	Section 2, Lot 932, Grid R-31/32
Lederer, Marge V.	97	Section 68, Lot 654
L'Enfant, Peter	39	Section 2, Lot S-3 S-34
Lejeune, John A.	65	Section 6, Lot 5682
Letterman, Jonathan	119	Section 3, Lot 1869
Lewis, George	22	Section 27, Lot 2230
Lewis, Samuel E.	26	Section 16, Lot 40-A
Lincoln, Robert T.	56	Section 31, Lot 13, Grid Y-38
Littlefield, Daniel	16	Section 26, Lot 5248
Louis (Barrow), Joe	83	Section 7A, Lot 177
Madison, Clinton R.	66	Section 3, Lot 4415
Mann, Joseph	21	Section 26, Grid QR-32/34
Marmaduke, Henry H.	32	Section 16, west side Confederate Monument
Marshall, George C.	96	Section 7, Lot 8198, Grid VW-24
Marshall, Thurgood	111	Section 5, Grave 40-3
Marvin, Lee	83	Section 7A, Lot 176
McAuliffe, Anthony	85	Section 3, Lot 2536, Grid P-16
McCampbell, David	84	Section 60, Lot 3150
McGee, Anita Newcomb	62	Section 1, Lot 526-B, Grid KL-34/35
McGuire, Thomas B. Jr.	84	Section 11, Lot 426, Grid O/14.5
McIntosh, Donald	59	Section 1, Lot 107D
McKinney, William H.	11	Section 27, Lot 98
Meigs, Montgomery C.	9, 49	Section 1, Lot 1
Murphy, Audie	87	Section 46, Lot 366-11, Grid O/P-22/23
Neal, Wiley Stuart	68	Section 18, Lot 2581
Nurses Memorial	63	Section 21, Grid M-19/20
Onassis, Jacqueline Kennedy	103	Section 45, Grid U-35
Packard, Albert H.	15	Section 26, Lot 5203
Palmer, George H.	40	Section 3, Lot 2104
Parks, James	12	Section 15, Lot 2, Grid G-26
Peary, Robert E.	121	Section 8, Lot S-15, Grid X-8.5
Pentagon Group	109	Section 64
Pershing, John J.	64	Section 34, Lot S-19, Grid U-12
Powell, John W.	120	Section 1, Lot 408, Grid L-35